BOOK OF SIDES

BOOK OF SIDES
ORIGINAL, SHORT SCENES FOR ACTORS AND DIRECTORS

Dave Kost

Focal Press
Taylor & Francis Group

NEW YORK AND LONDON

First published 2015
by Focal Press
70 Blanchard Road, Suite 402, Burlington, MA 01803

and by Focal Press
2 Park Square, Milton Park, Abingdon, Oxon OX14 4RN

Focal Press is an imprint of the Taylor & Francis Group, an informa business

© 2015 Taylor & Francis

Notices

Knowledge and best practice in this field are constantly changing. As new research and experience broaden our understanding, changes in research methods, professional practices, or medical treatment may become necessary.

Practitioners and researchers must always rely on their own experience and knowledge in evaluating and using any information, methods, compounds, or experiments described herein. In using such information or methods they should be mindful of their own safety and the safety of others, including parties for whom they have a professional responsibility.

Product or corporate names may be trademarks or registered trademarks, and are used only for identification and explanation without intent to infringe.

Library of Congress Cataloging-in-Publication Data

Kost, Dave.
 Book of sides : original, short scenes for actors and directors / Dave Kost.
 pages cm
 1. Monologues. 2. Acting—Auditions. I. Title.
 PN2080.K68 2014
 812'.6—dc23
 2014002825

ISBN: 978-1-138-02226-3 (pbk)
ISBN: 978-1-315-77720-7 (ebk)

Typeset in Palatino
By Apex CoVantage, LLC

Printed and bound in the United States of America by Sheridan Books, Inc. (a Sheridan Group Company).

For Kelly, my favorite actor.

CONTENTS

ACKNOWLEDGMENTS

Thanks to all those who helped in the development of this book.

Most especially, thanks to those who reviewed the book's manuscript, particularly my friend and colleague at Chapman University, Jay Lowi, for all his time and crucial feedback. Also, thanks to Jack Sholder of West Carolina University for his valuable notes. Thanks as well, to my wife, Kelly Herman of Cal State Dominguez Hills, for her many great ideas and all her support.

My gratitude to all those involved in the review of this book's proposal, especially my great friends and colleagues at Chapman University, John Benitz and Gil Bettman, as well as Catherine Hurst of Saint Michael's College and John Thies, Artistic Director of Hothouse Improvisation. Without their support and feedback this book may not have been possible.

Completing a book is much easier in the right environment. For that, I thank all my fellow professors at Chapman University both in and out of the film school. It is rewarding to work in such a collegial environment and be surrounded by people as passionate about education as I am. My appreciation also to the Chapman staff, especially those in the film school who are so helpful on a daily basis, and my gratitude to all of Chapman's administrators who have been so supportive during my many years here.

In creating the photos for the book, I was assisted by John Manning who took most of the pictures. Thanks to him as well as the Chapman students who served as the subjects of the photos: Brandon Burtis, Olivia De Boutray, Matt Gallenstein, Marie Oldenbourg, and Donathan Walter.

It has been a pleasure working with Focal Press and Taylor and Francis. Thanks especially for the help and support of Emily McCloskey, Dennis McGonagle, Peter Linsley, and Denise Power.

Finally, thanks to all my students. Their energy and eagerness to learn are a constant inspiration to me. More specifically, thanks to the students in Chapman's Screen Acting program, especially those I have been lucky enough to have in my classes. Working with them is where I discovered the need for a book of single-page scenes, and only after having these talented young actors work with my first batch of short scenes did I know I had a truly valuable resource that needed to be shared.

FOREWORD

It is the aspiration of this book to provide new options for scenework that will facilitate innovative learning experiences. For reasons that have more to do with the available source material than the needs of acting, directing, and audition workshops, previous scene books feature scenes ranging in length from four to eight pages. They frequently feature the work of great writers of the stage and screen and have been used to successfully train actors and directors for decades. This book will not supplant those books. Instead it will complement them, providing a new and different form of scene that will expand the currently limited options available for students studying film and theater.

The short length of these scenes is their most important distinction. Many of the most essential lessons of scenework are learned from the decisions the aspiring actor or director makes in approaching the material. More can be gained by attempting two short scenes than one long scene, especially when students are just starting out. While working at a quicker pace will be a good introduction to scenework, the length and other unique aspects of these scenes may be useful to students at any level.

Most scene books are compiled from existing play or movie scripts, but the scenes in this book are original because it would be difficult or impossible to find existing one-page long scenes that feature both actors equally, contain conflict, and don't feel like scene fragments. The scenes in this book were designed specifically for scenework, even making them universally castable, something impossible with scenes from existing material that invariably dictate the gender of the characters and sometimes age, ethnicity, or type as well.

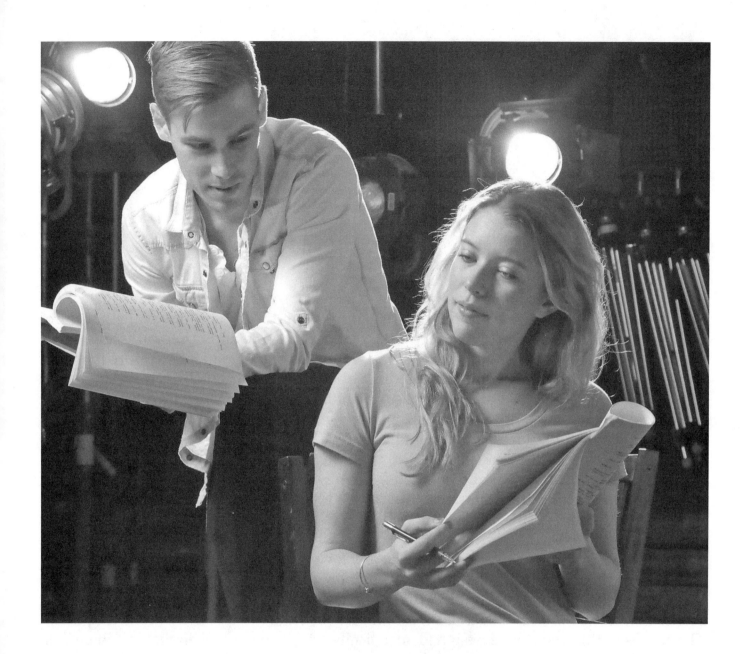

INTRODUCTION

SCENEWORK

Scenework is the performance of scenes in a classroom setting. It lies between strictly theoretical study and practical experience in the making of complete films or theatrical productions. It is where aspiring actors and directors can acquire most of their experience, get mistakes out of the way in a safe, constructive environment, and develop good habits.

A musician can only learn so much from a book and will only master their instrument by actually playing it. At the same time, it is not practical or advisable that aspiring musicians leap directly into performing in concerts, so they do what only makes sense, spending the bulk of their musical education practicing. Simplified exercises make the basics come easily, almost automatically, allowing more and more concentration to be shifted to nuance, detail, and the perfection of the craft.

Serious training in dance, graphic arts, and creative writing all use simple exercises to focus on building skills one at a time. This educational approach is perhaps even more important in film and theater where mounting actual productions requires so much effort and so many resources. Scenework, on the other hand, requires no more than scenes, actors, a director, and a little space. It should be simple in its presentation so that all the focus can be put on improving the skills of the actors and directors though practice and criticism. In order to meet its educational end, scenework should not require sets, costumes, or elaborate props. The scenes in this book do not require any such complications.

Even when scenework is shot and edited—as is advisable at times for those studying film directing or screen acting—there is no need to put effort into production value. A location should be selected for convenience. Any well-lit, sound-friendly environment will do. The object is to keep the production simple in order to focus on specific goals to be achieved in the performances, so that the skills related to these goals can be improved.

Best of all, scenework can be presented in a classroom where it can be workshopped with a skilled mentor who can be a guide in the process of creating convincing and dramatically involving performances. Scenework is the quickest and most effective way for aspiring actors and directors to learn their craft because it facilitates a lot of practice and a lot of feedback.

Getting the Most Out of Scenework

To learn as much as possible from scenework, students need to embrace the right process in their approach to the work. Although scenework is just practice, it needs to be

approached with the same effort, energy, and preparation as a fully-realized production. What is learned from scenework is commensurate to the effort put into it.

At the same time, one of the benefits of scenework is that it should not create the same pressure as working in a large production. The work still must be taken seriously, but the participants should be freer to focus on narrower goals, more open to varying approaches, and more willing to take risks. Successes and failures will all be learning opportunities especially when accompanied by supportive critical feedback from instructors and peers.

The Goals of a Scene

The goals of scenework are all related to performance, but there are a great many aspects to a successful scene or performance. It is not possible, especially for those new to acting and directing, to successfully execute or even attempt every aspect of a performance at the same time. Short scenes are ideal for focused, incremental growth. All attention can go to one particular aspect of a performance, it can be improved, and then attention can be shifted to another aspect. Understanding the different elements of a successful scene will help in setting focused goals that are appropriate at various stages in an actor or director's education.

There is a whole body of great literature about acting and directing, and those serious about acting and directing are encouraged to read extensively on the subject, but a brief summary of the various aspects of a successful scene are presented here as a primer for those getting ready to work with the scenes in this book. Without being too proscriptive, an effort has been made to point readers toward more basic or more advanced aspects of scenework.

Believability

Whether a performance is believable or not will depend on several factors. The most basic of these is whether the actors seem to spontaneously respond to one another rather than just read lines. Genuine reactions are impossible when the script is known in advance and it only gets more difficult with more repetition. It takes practice and skill to truthfully reproduce spontaneity in a scene and most acting training begins with the basic goals of listening, processing, and reacting as a means of creating believably spontaneous exchanges between actors. This is the foundation on which a believable performance is built.

Character Building

Believable characters are complete people. They should have dimension, with full lives and histories, needs and desires. Even for scenes as short as those in this book, actors should know their characters and ground them in specific detail. What kind of people are they? What kind of relationship do they have with the other character in the scene? What do they want from the other character in the scene and why do they want it? What were they doing just before the scene began? Character biography or backstory, given circumstances and the moment before are basic components of acting training and basic goals of scenework.

Emotional Reality

A performance's believability also hinges on the truthfulness of the emotion manifested by the actors. Some actors may have difficulty producing any emotion, while others may force too much. The results can either be too dry or too melodramatic.

Inexperienced actors will have difficulty expressing a full range of emotions. Some will believably manifest joy, but struggle with anxiety; others will convincingly manifest sadness, but struggle with anger. Most actor's training helps actors to access their emotions with many techniques. Beginners will want to start out in an emotional range where they are comfortable, especially as they are mastering a believably spontaneous exchange. More advanced actors and directors will want to deliberately attempt more challenging emotions.

Dramatic Interest

A performance will not be watchable merely because it is believable. It should be dramatically engaging as well. Some writing will be more dramatically interesting and some less, but it is always the aim of actors and directors to bring out as much dramatic interest as possible through the performance.

Subtext

Subtext refers to the emotions and intentions that lie beneath a character's surface. Characters having a polite exchange of dialogue will be boring to watch, but if there is hostility bubbling just below the surface in a polite exchange, it will be absorbing. Subtext makes the audience not just passive observers but active participants, working out what is really going on in a scene and the true nature of the characters.

Some scenes give a clear idea of what the subtext should be, while others only hint at it. Scenes that don't appear to have subtext at all still have room for the actors to creatively supply it and it will always add to the scene. Although short, every one of the scenes in this book provides the opportunity for both characters to have subtext.

Subtext is basic to a scene, but it is a more advanced challenge to make sure the subtext is played in such a way that the audience can pick up on it without it seeming like the actor is indicating their underlying feelings.

Conflict

Conflict is the center of dramatic interest. Without it, a scene is boring and trivial. Conflict makes a scene more intriguing by adding uncertainty to its outcome. How will the conflict resolve? Who will prevail? We are also drawn to conflict because we instinctually relate the struggles of the characters to the struggles in our own lives. The most common and yet most complex struggles we all deal with are conflicts with other people. This is why almost all scenes, and certainly all those in this book, are built around characters with mutually exclusive objectives.

Sometimes the conflict in a scene is very clear, other times it needs to be brought out through subtext. In this way, subtext and conflict are related. Even a scene with explicit conflict will benefit from subtext suggesting conflict at a deeper level.

Conflict exists at two levels: external conflict—the conflict between characters, and internal conflict—the conflict within a character. The combination of external conflict with internal conflict adds subtext and complexity which increases the scene's dramatic interest. The conflict in a scene where one character desires more commitment and the other does not will quickly reach an impasse if both characters are completely set in their positions. However, if one or both characters are internally conflicted about their desire for commitment, there is room for the conflict to develop.

Conflict is more intense if more is at stake. Stakes are what is motivating a character toward their objective. A performance should convey what a character stands to gain or lose depending on the outcome of the conflict. Sometimes the stakes will be strong and explicit in the scene, but other times it will be a challenge to find what is at stake in a scene. Even a scene with conflict can come off as petty bickering unless the actors and director motivate the characters with fears and desires that become part of their subtext. Stakes are more compelling if they are emotional. If a character's objective is something material like money, this will not be very involving unless the performance suggests that the money is needed for emotional reasons: to feed a starving family, maintain basic dignity, or realize a dream.

Mutually exclusive objectives require that each character needs the other to relent. If characters don't need each other, there is nothing to sustain their conflict. The audience may wonder why conflicting characters don't just go their separate ways unless they also see how they need each other. For instance, the conflict in any scene between lovers will be more compelling if the audience can see both what is tearing them apart and what still holds them together.

Identifying the objectives of characters and using them to create conflict is basic to drama, but playing the conflict at two levels as well as building stakes and need into a scene are more intermediate aspects of scenework.

Structure

Structure in a scene refers to the progression of the conflict and the change in the characters' relationship. A scene will lose dramatic interest if it is repetitious or if it does not move the relationship of the characters forward. The scenes in this book are no exception.

The progression of the conflict in a scene will add to dramatic interest especially if it makes the outcome of the conflict more uncertain. The characters themselves should seem uncertain about how the conflict will resolve. Because the actors know how the scene ends, they sometimes play the whole scene with the emotional note of the scene's ending. This telegraphs the outcome of the conflict to the audience and halts the progression of the scene. In a scene about estranged lovers trying to reconcile, the characters should have both hope and dread, but an actor who falls into the trap of playing the result will only play dread if they know the lovers do not reunite in the end.

The outcome will seem most uncertain when it seems to shift. In a two-character scene, this means that it should seem like one character will prevail one moment and the other character will prevail the next. To achieve this, care must be paid to the specific ways in which the characters try to get what they want. The characters should start with strong tactics, but will need to counter each other with stronger and stronger tactics in order to prevail. Most acting training puts an early emphasis on tactics and the use of action verbs to create intentions behind the delivery of lines.

To create uncertainty of outcome, actors must also be open to their scene partners and truly be responsive. Actors can get so wrapped up in their own objectives and tactics that they fail to be affected by the actions of the other actor in the scene. It is more involving to see characters that are vulnerable and can be shaken by the actions of other characters. We recognize our own vulnerabilities in them and will want to see them regroup and dig deeper in order to counter.

Playing actions or intentions helps with the basic goal of spontaneity while being open and vulnerable asks the actors to go deeper. In more advanced scenework, tactics can be made more interesting and surprising and can be shaped to achieve a balance that creates a stronger back and forth in the possible outcome.

Scenes in movies and plays exist to advance the story. This means that things change between the characters by the end of the scene. Even if there is a great deal of back and forth in a scene, if the relationship of the characters is exactly the same at the end of the scene as it is at the beginning, the scene is literally pointless. When the relationship changes, this often means that one or both of the characters has changed as well. The change in some scenes may be a major turning point like a break up or reconciliation. In others, it may be a small shift between two characters in understanding, intimacy, or balance of power. As short and simple as the scenes in this book are, they all provide the advanced challenge of showing a change either big or small.

Blocking and Movement

The physicality of the actor is as important to the performance as the way they delivers the lines. It should be taken into account in every aspect of the performance from subtext to conflict, but for less experienced actors, movement may be too much to think about and may interfere with more fundamental goals of the scene. There is nothing wrong with early scenework being performed from a seated or simple, standing position. Most auditions will be performed static as well.

Movement is an entire discipline of acting training. Freeing an actor physically often takes time, but the importance of movement and blocking cannot be understated and every aspect of the physical performance, from posture and gesture to the physical relationship of the actors can be utilized in the performance.

Blocking is of particular interest to the director in expressing the subtext of a relationship between characters. Those using scenework to study directing should experiment with the physical relationship of their actors to create dynamic shifts that express the loss or gain of intimacy or power between characters.

Style and Technique

Believability is not synonymous with realism. Many styles of performance, including most comedy, require the actor to act in a way that is not strictly true to life. The performance still needs to be believable, especially at an emotional level. The emotional reality that needs to underlie all performances is what makes acting in a style truly difficult.

For this reason, it is highly advisable that beginners start with simple, realistic scenes, and after consistently and successfully creating a believable performance in this type of material, they will be better equipped to bring emotional reality to more stylized work. The scenes in this book are not particularly proscriptive of style. Many could be played as straight drama or over-the-top comedy, so they may be attempted at different times in the training of actors and directors with different stylistic goals.

Similar to the stylistic layers that can be added to a performance, technical layers can also be added. A technical layer might be a dialect or accent, a physical impediment such as a handicap or injury, or a mental impediment like drunkenness or psychological disability. These are

generally more advanced challenges for actors, but chosen well they can add dimension to a character and may even contribute to the dramatic interest.

DIRECTING AND ACTING CLASSES

Scenework is an important part of both acting and directing classes. How to get the most from scenework and the general goals of scenes as outlined above are the same for actors and directors. Both need to embrace the learning process with effort and discipline and work towards creating believable exchanges with dramatic interest. In addition, both actors and directors should focus on learning vicariously from the work of their peers, not just watching and providing helpful suggestions, but acting or directing their classmates' scenes in their own minds. These similarities aside, the way in which directing, acting, and also audition classes work are by necessity different.

Acting Workshops

When scenework is done in acting classes, it is generally done with the instructor functioning as director. The instructor's direction is aimed at improving the performances in the scene, but more importantly, it is meant to facilitate the growth of the actor based on where the actor is in their training.

Actors need to come to scenework prepared. They should know their lines. In most circumstances, they should have even rehearsed their lines with their scene partners, but should not have locked themselves into any specific choices. They should have made determinations about their character's given circumstances, objective in the scene, and tactics, but again, they cannot be rigid. They will need to mesh their performance with their scene partner's and be responsive to the instructions of the director or teacher. In fact, actors should not just be ready, but eager to explore options in the performance. A real actor's prep does not just dictate one possible direction for a character or scene, but offers options that can be explored with the scene partner, director, or instructor.

It is important that actors try to focus on one or two learning goals appropriate to their personal development, but in a classroom environment, they may need to bend their goals to those of their scene partners or the class, and they need to work on whatever the instructor or director chooses. If actors hope to gain anything from a class, they must be accepting of the process of the instructor whatever that may be. Good actors build trust with their directors and always try to give their directors what they want. This attitude needs to begin in the classroom.

Directing Workshops

When scenework is done in a directing class, the directors need actors to direct. They must either recruit actors to be in their scenes or use other directors from the class as actors. Using other directors will be useful when working on basic goals of scenework, and the experience of acting will be good for directors, but as they progress, directors will need actors with more and more experience in order to work on more advanced aspects of realizing scenes.

That said, whether a director feels they are working with superior or inferior actors, their goal remains the same, to get the most out of all those they work with. More important than

an actor's ability is that they be fully engaged in the process, so that the director has a real chance to work with them and help them perform to the best of their capabilities.

Like actors, directors also need to come to scenework prepared. They cannot competently direct a scene if they have not first made determinations about both characters' given circumstances, objectives in the scene, and tactics. They can't be rigid, though, and need to be open and receptive to the ideas of their actors and instructor. In most circumstances, they should have rehearsed with their actors outside of class. They should have explored options with the actors and done all they can to get the scene as far as they can. Once the scene is brought to class, they need to be responsive to the instructor, welcoming constructive criticism, and eagerly experimenting with any suggestions.

To get the most out of actors, it is important for directors to embrace them as collaborators. Directors should work to listen to and incorporate their actors' suggestions. Actors are likely to become disengaged if they feel their director is dictating the performance rather than nurturing it, particularly if the director demonstrates the performance or gives line readings. Without the actor's trust, the director will have little ability to shape the performance.

Directors should also be careful not to overwhelm their actors with notes. A performance should be improved incrementally with adjustments, small directions between each rehearsal. Adjustments should allow the actors to focus on one or possibly two specific changes in their performance at any time.

Not all instructors run directing workshops the same way. Some instructors work with the student-directors allowing them to do all communicating with the actors themselves while other instructors step in and work with the actors directly as a demonstration. In either case, it is important for the director to be accepting of the process of the instructor. A good director is not satisfied with only their ideas, but embraces and actively encourages suggestions from those around them. This attitude needs to begin in the classroom.

Audition Workshops

Scenework is most often done as practice for finished performances in film or on stage, but it can also be useful as practice for auditioning. Since so much of an actor's success depends on their ability to audition and so much of a production's success depends on its casting, practicing auditioning is extremely valuable for both actors and directors.

The short scenes in this book are particularly useful for audition workshops since most audition sides are not much longer than a page. Auditions differ in the amount of prep time allowed, so it will be valuable to allow the scenes to be prepared ahead of time (though for an audition, they need not be memorized) and it will be equally valuable to attempt the scenes with little or no prep, putting the script into the actors' hands and having them immediately perform what is called a "cold read."

Any time an actor is reading from a script, it is important to not let that reading interfere with listening, processing, and responding believably. Actors should develop the habit of checking their next line in the script immediately after delivering their own line because this is when the auditioner's attention will have shifted to the other actor in the scene. They should have their attention back to the other actor before the other actor finishes their line so as not to distract from the most important moment of their performance, their reaction.

In all auditioning, it is important for the actor to make strong choices that highlight their individual strengths and differentiate them from the others auditioning. Bold choices make

actors stand out in a crowded marketplace. Actors should be willing to take risks, and only avoid choices that get in the way of meeting the goals of the scene. In most cases, actors will want to differentiate their performance by allowing their own individual personality into their work, especially their auditions.

Directors need to approach auditioning remembering that they are not trying to work towards a finished performance. Whether an actor is appropriate to a part can be gauged relatively quickly. It is more difficult and takes more practice to learn how to judge what an actor will be like to work with. Directors need to gauge the creativity and responsiveness of the actor auditioning and should work to try to stretch and push them, testing them as collaborators. In many cases, the director should intentionally ask the actor to move away from the best interpretation of the scene in order to see how the actor responds to a stronger direction or to push the actor out of their comfort zone.

SUMMARY

Creating truthful, dramatic behavior under imaginary circumstances is the essential job of actors and directors. It is deceptively difficult to master. Actors and directors will develop most quickly by concentrating on their learning process and putting it ahead of any result. They need to put their best effort into all their work, take risks, be open to feedback, and work at focused, incremental growth.

They also need to maintain a positive attitude and should be careful not to put undue pressure on themselves while they are learning. They are undertaking a long process in a difficult business. If they can't make this journey fun for themselves, it's simply not worth it.

Above all, young actors and directors need as much experience as they can get and need to make sure as much of that experience as possible is focused simply and squarely on creating compelling performances.

Scenework is the ideal vehicle for this process and the scenes in this book should prove particularly useful. Good luck!

 CHRIS
 Am I attractive?

 JODY
 What? Sure. You're young, you're good
 looking. What are you worried about?

 CHRIS
 Not just my looks, I guess. Am I an
 attractive person? The whole package?

 JODY
 Okay... what's this about?

 CHRIS
 Nothing. I just wanted to know.

 JODY
 Nobody "just wants to know" something
 like that.

 CHRIS
 Can we not get into this?

 JODY
 Ah-ha, there's somebody isn't there?

 CHRIS
 Yeah, kind of, but really, that's all
 I'm going to say.

 JODY
 Ainsley? Harper? Shawn? Jude? Mel?
 C.K.? You have to tell me. I can go on
 like this all night.

 CHRIS
 You. Okay? You.

 JODY
 Me?

 CHRIS
 Yeah. So... am I an attractive person
 or not?

Jody takes it in for a long moment, then smiles.

 JODY
 Yeah.

 RIVERA
Are we really friends?

 SYDNEY
Whoa! Where's this coming from?

 RIVERA
It's just that... I always pay.

 SYDNEY
Is that what you think? I only like you
for your money?

 RIVERA
Well we do stuff together, we club, we
go out, travel even, but when do we ever
just hang out?

 SYDNEY
So what? You don't want to go out
tonight? No worries. I don't care.

 RIVERA
Really? That's a relief. Because, I
need to tell you... I'm broke.

 SYDNEY
What? Like no money on you, right?

 RIVERA
No. Like no money left. Period. It's
a whole thing with my dad. He's in real
trouble, but yeah... broke.

 SYDNEY
Wow. Bummer... Really sorry to hear
it, but yeah, of course we're still
friends. Of course! We'll hang out...
When were you thinking?

Sydney heads for the door.

 RIVERA
Not tonight?

 SYDNEY
Oh, not tonight, busy, but soon. I'll
call...

 RIVERA
Yeah, call.

Alva walks in and Tracie looks up.

> ALVA
> Why'd you tell Mickey you were out of town last weekend.

> TRACIE
> Oh, I was just trying to avoid a whole thing.

> ALVA
> What whole thing?

> TRACIE
> Nosey much?

> ALVA
> I don't care about Mickey, I just want to know, did you lie or are you a *liar*?

> TRACIE
> What does that even mean?

> ALVA
> You've told me you were busy before.

> TRACIE
> That's different.

> ALVA
> Is it? Maybe you were avoiding a "whole thing" then too.

> TRACIE
> Really? Mickey's Mickey and you're you. You know we're good don't you?

> ALVA
> I thought I did.

> TRACIE
> You do. Of course you do. I did lie, I wouldn't lie to you. I'm not a *liar*. I swear.

Alva considers a long moment.

> ALVA
> Yeah, I don't think I believe you anymore.

 DARRYL
Are you a team player?

 JOHNNIE
Of course. What do you need? Name it.

 DARRYL
This is one of those times when we
really need to come together.

 JOHNNIE
Hey, I'm a hundred percent onboard.

 DARRYL
Good. You remember the Farley account
that you were working on last week.

 JOHNNIE
Yeah.

 DARRYL
You need to forget you ever saw it. You
need to forget that account even exists.

 JOHNNIE
Okay...

 DARRYL
Alright. Now, what do you know about
the Farley account?

 JOHNNIE
Uh... What's the Farley account?

 DARRYL
Perfect. And that's the answer you'll
have no matter who's asking.

 JOHNNIE
Wait, who's going to be asking?

 DARRYL
I ask again, are you a team player or
not?

Johnnie considers a long moment.

 JOHNNIE
I'm a team player... but how much does
this company value its team players?

Tracy approaches MAL cautiously.

 TRACY
 You angry at me?

 MAL
 No.

Tracy stares, unconvinced.

 MAL
 Just leave me alone.

 TRACY
 You are definitely angry.

Mal sighs.

 MAL
 Okay, I'm angry, but not at you,
 alright?

 TRACY
 Then why are you taking it out on me?

 MAL
 I asked to be left alone, how is that
 taking it out on you!?

 TRACY
 You're yelling at me, that's taking it
 out on me.

 MAL
 I'm yelling at you because you won't
 leave me alone.

 TRACY
 I'm not leaving you alone because I want
 to know why you're mad at me.

Mal stares in enraged disbelief. Suddenly Tracy laughs.

 TRACY
 Just yanking your chain with that one.
 I get it. I'm going. Lighten up,
 though, huh?

Tracy walks away. MAL boils.

 MAL
 Now I am mad at you!

Yoshi walks in agitated.

> **YOSHI**
> Are you cheating?

> **CHANCE**
> Wow. Where'd that come from?

> **YOSHI**
> Answer the question.

> **CHANCE**
> No. Now answer *my* question.

> **YOSHI**
> I looked at your phone.

> **CHANCE**
> Are you kidding!? I can't believe you.
> How could you? Don't you have any
> trust? Any boundaries?

> **YOSHI**
> Who's Tracy?

> **CHANCE**
> Don't try to dodge this. Where do you
> get off looking at my phone?

> **YOSHI**
> Really not the issue right now.

> **CHANCE**
> I think it is, but I'll indulge you.
> Tracy is McIntyre, the new supervisor at
> work I told you about.

> **YOSHI**
> I... I'm sorry. I'm so sorry.

> **CHANCE**
> You sure are.

> **YOSHI**
> Please. Let me explain.

> **CHANCE**
> Explain it to somebody who cares.

Chance walks out.

Cass walks in and considers Kelly.

 CASS
 Would you mind leaving?

 KELLY
 What's going on?

 CASS
 I've got someone coming over is all.

 KELLY
 Oh. And you don't want me here?

 CASS
 Is leaving a problem?

 KELLY
 No. I just kind of want to know why.

 CASS
 I just want... some privacy, okay? I
 really don't have time for this. Can
 you just leave?

 KELLY
 Wow. Do you not want whoever this is to
 even see me, or what?

 CASS
 Please, just go.

 KELLY
 Are you embarrassed by me?

 CASS
 Good God, what is wrong with you. Why
 have you made this into a huge deal. I
 just want some privacy.

 KELLY
 I'm going to take that as a "yes".

Kelly gets up and sullenly walks out.

 CASS
 If I was embarrassed by you this
 behavior here would be why.

 KELLY
 See, I knew it.

STORM
You need an attitude adjustment.

ARDEN
I'd like to see you try.

STORM
See that's exactly what I mean. You're
hostile. You're a hostile person.
Nobody likes a hostile person.

ARDEN
I'm not hostile.

STORM
Really? "You'd like to see me try"?

ARDEN
I just said that because I thought you
were trying to sort of challenge me.

STORM
Yeah? And so anytime you feel
challenged, you get hostile?

ARDEN
No one likes to be challenged.

STORM
Most people don't respond with a threat.

ARDEN
Okay, so I get hostile, but that doesn't
make me a hostile person, does it?

STORM
What does it make you then?

ARDEN
Wow, so what should I do?

STORM
All you have to do is smile.

Arden smiles big if a little strained.

STORM
Good, now do it when you're angry too.

ARDEN
Even when I'm kicking someone's ass?

 TUCKER
 I got *the* best plan for tonight.

 YAZ
 Bad idea.

 TUCKER
 What? What do you mean? I didn't say
 anything yet.

 YAZ
 Doesn't matter. All your ideas are bad.
 They're nothing but trouble.

 TUCKER
 What are you talking about? We have fun
 don't we?

 YAZ
 You have fun. I either get in trouble
 or worry about getting in trouble.

 TUCKER
 Where's this coming from? You never
 said anything about this before.

 YAZ
 I'm a slow learner.

 TUCKER
 Ouch. You're making me feel bad.

 YAZ
 You should.

 TUCKER
 Sorry. I don't know what to do...

 YAZ
 Just leave me alone.

 TUCKER
 Wow. Are we... not friends anymore?

Yaz sees that Tucker's hurt and softens.

 YAZ
 I shouldn't lay this all on you. I'm
 mad at myself, really. We can do stuff,
 just no more... bad ideas.

Fowler walks in agitated.

> FOWLER
> Drew's going out with Abney.

> DEZ
> Oh no! You liked Abney, right?

> FOWLER
> Yeah.

> DEZ
> Wow. Drew? Drew's a total douche.
> What's that all about?

> FOWLER
> I'm going to start being a douche.
> Better to be a douche, I think.

> DEZ
> No. You're nice. Better to be nice.

> FOWLER
> Why? What do I get out of it?

> DEZ
> Well... I like you for it.

> FOWLER
> Of course *you* do.

> DEZ
> What does that mean?

> FOWLER
> We always watch your shows and go to
> your movies and do what you want to do
> and eat what you want to eat, don't we?

Dez considers, surprised.

> DEZ
> We do? Really? What does that make me?

> FOWLER
> You do the math.

> DEZ
> You know, that right there, that's a
> pretty good start on being a douche.

 ADDISON
 Bitch!

Geo is startled.

 GEO
 Don't say that. That is not cool. That
 is not something you should be saying.

 ADDISON
 Whatever, bitch!

 GEO
 Seriously, not cool. I don't know what
 your problem is, but please, stop with
 the bitch thing.

 ADDISON
 Or what, bitch?

 GEO
 What's the problem here? Did I miss
 something?

Addison just stares defiantly.

 GEO
 Okay. Fine. I'll just go then.

 ADDISON
 What a...

 GEO
 Bitch! Bitch! I'm a bitch. Yes, I get
 it. What is wrong with you? Can't you
 just let it go?

Addison smiles.

 GEO
 What are you happy about? What is wrong
 with you? What kind of person are you?

Addison walks away triumphantly.

 ADDISON
 At least I ain't no bitch.

Geo struggles not to explode.

Wes approaches Bryn who backs up.

> WES
> Can I borrow your phone?

> BRYN
> Sorry. I don't know you.

> WES
> I lost my phone. I've got no way home.
> I just need to make one call.

> BRYN
> Sorry.

> WES
> Really? What do you think I'm going to
> steal it or something? I'm not gonna
> steal it, I swear.

> WES
> That's great. Please, go... and don't
> steal someone else's phone, okay?

> BRYN
> Do I come off as a criminal or
> something?

Wes smiles.

> WES
> You really want to know? My phone was
> stolen before. Pretty much exactly like
> this, so no way am I giving it to you.

> BRYN
> Really? What an idiot. You just handed
> your phone to a stranger?

They both stare a moment, then Wes laughs. They laugh
together.

> WES
> Okay, that was funny. I'm sorry. I
> don't wanna be that person. Here.

Wes hands over the phone. Bryn takes it and immediately runs
away. Wes yells.

> WES
> Okay, now this is not so funny!

Izzy and Dann wait next to each other.

 IZZY
 Can I tell you something?

 DANN
 Do I know you?

 IZZY
 No, but this will be easier with a
 stranger. See, I've done something
 terrible. I just need to tell someone.

 DANN
 Don't you have a priest or a Rabbi or
 something? Go tell your therapist.

 IZZY
 I may change my mind. What do you have
 to lose? I'll tell you, I'll feel
 better and you'll go on your way.
 Consider it a good deed.

 DANN
 Okay... What?

 IZZY
 I had an affair. I cheated. I cheated
 on the best person I know.

 DANN
 Wow.

 IZZY
 Awful, right?

 DANN
 I... I cheated, too. I don't even know
 why. It wasn't like I was in love or
 even that attracted... Four years ago
 and I still hate myself for it every
 day.

 IZZY
 Sorry, I didn't mean to dredge stuff up.

 DANN
 No... No... You were right. It is
 good to tell someone.

They share a weak smile.

 ROSARIO
Dale is moving out.

 PAGE
Oh no! When?

 ROSARIO
End of the month.

 PAGE
Crap! We need to find a new roommate.

 ROSARIO
I don't know, it would be nice to have
the living room back.

 PAGE
It'll be extra rent for us. Could we
afford that?

 ROSARIO
Oh. I guess if you can't afford it, it
doesn't matter about me.

 PAGE
Wait. I'm not trying to make this
decision for us.

 ROSARIO
Don't be embarrassed. I understand.

 PAGE
I'm not embarrassed. That's not it.

 ROSARIO
Then what?

 PAGE
I... guess I was just stuck thinking how
things are now with the three of us.

 ROSARIO
Really?

 PAGE
Yeah, totally.

 ROSARIO
Awesome. We should go TV shopping then.

Rosario walks out excited and Page's face falls.

 RIPLEY
 Can you hold this for me?

Ripley extends a bag toward Xuan, who backs away.

 XUAN
 What? Sorry, do I know you?

 RIPLEY
 I'm just asking for a favor. Hold this
 for me for a minute. It's no big deal.

 XUAN
 What in this?

 RIPLEY
 Nothing bad. Just hold it for a second.
 I'll be right back, I swear.

 XUAN
 I'm really not comfortable with this.

 RIPLEY
 You so looked like a good person, a nice
 person, the kind of person you turn to
 when you need help. It must be me. Am
 I just inherently suspicious, or what?

 XUAN
 No. I don't mean to be... I don't
 know... Please, just find someone
 else... please.

 RIPLEY
 Here? Who do you suggest?

Ripley looks around.

 XUAN
 I don't know, I... Really...

 RIPLEY
 Never mind, I didn't mean to make you so
 uncomfortable. I really didn't.

Ripley backs away, but Xuan extends a hand.

 RIPLEY
 Thank you so much. Thank you!

Ripley hand over the bag, smiling and sprinting away. Xuan
holds the bag at arms length, frozen in place and mumbling.

 BAI
Can you put a word in for me with Dylan?

 LAUTNER
I can't imagine that'll do any good.

 BAI
Dylan's your friend. Dylan listens to
you. It couldn't hurt, just do me a
favor and say a few nice things about
me, okay?

 LAUTNER
I'll try.

 BAI
What do you mean, try? Is it so hard?
Just pick up the phone.

 LAUTNER
What is it you want me to say?

 BAI
Say something nice... my strengths...
Whatever...

 LAUTNER
Like what, specifically?

 BAI
Do you really not have anything good to
say about me?

 LAUTNER
Sure. I just want to be on the same
page with you.

 BAI
I don't know... Say I'm hard working and
easy to get along with, I guess.

 LAUTNER
Easy?

 BAI
You know what? Just forget it. I'm
sorry I asked.

Bai storms out. Lautner breathes a sigh of relief.

 MARCH
Has anybody talked to you?

 CHANDRA
What do you mean?

 MARCH
Uh... I need to talk to you.

 CHANDRA
What? You're scaring me.

 MARCH
Sorry. Maybe you want to sit down or-
I really don't know how to do this.

 CHANDRA
Do what? What's going on? What
happened?

 MARCH
Yeah, sit down, you should definitely
sit down. Sit down, please.

Chandra finally sits. March sits too.

 MARCH
No idea what I'm doing here... I'll just
spit it out... Umm... Casey's dead.

 CHANDRA
What?

 MARCH
There was an accident. All the details
aren't clear, yet, but Casey... died.

 CHANDRA
Oh, my God... I thought it was my Mom
for sure... or at the very least,
Bertie. I mean... I liked Casey and
this is terrible... but... all I can
feel is relief. Am I a horrible person?

 MARCH
I don't think so. I'm relieved too. I
was just so worried about how you would
take it.

They share an awkward smile, then feel guilty for smiling.

> DEVON
> Did I do something wrong?

Devon approaches Tommie. Tommie is a little distracted.

> TOMMIE
> No. We're good.

> DEVON
> It's just... I feel like something's
> changed.

> TOMMIE
> I'm the same, you're the same, right?

> DEVON
> Yeah, but are *we* the same?

> TOMMIE
> You're losing me now.

> DEVON
> I don't know... I just don't think you
> share stuff with me like you used to.

> TOMMIE
> Like what?

> DEVON
> Anything... I don't know... You don't
> share it anymore, so how can I know?

> TOMMIE
> We talk all the time.

> DEVON
> Not like we used to.

> TOMMIE
> We are a little older, a little
> different. We've changed. Things can
> never stay exactly the same.

> DEVON
> I don't want things to change. I'm not
> changing them. You're the one changing
> them.

> TOMMIE
> Sorry. Change just happens.

Meade walks in and sees Cary writing.

 CARY
 What is that, a job application?

 MEADE
 College application.

 CARY
 College?

 MEADE
 You don't have to say it that way.

 CARY
 Just a surprise, you weren't the most
 impressive of students in high school.

 MEADE
 What's that got to do with anything?

 CARY
 Well, for starters, college is harder.

 MEADE
 So what should I do, dig ditches?

 CARY
 There's plenty of good jobs you don't
 need college for. Any idea what an
 electrician or a plumber makes?

 MEADE
 Those things don't interest me.

 CARY
 Ah... So what does interest you?

Meade hesitates a moment.

 MEADE
 Economics.

 CARY
 Economics... Well, now I understand.
 That's easy, you don't need to be a good
 student for that. Perfect for you.

 MEADE
 You're real funny, but your sarcasm's
 not going to stop me.

Jie is getting ready to go, but sees London and stops.

> JIE
> We're going out for drinks.

> LONDON
> Again? Have fun.

> JIE
> Come with.

> LONDON
> I'm good.

> JIE
> C'mon. It's been ages.

> LONDON
> Thanks. Not tonight.

> JIE
> You used to be fun.

> LONDON
> I have to go out drinking with you and
> your friends to be fun?

> JIE
> It's a start.

> LONDON
> Ha ha. Just go already.

> JIE
> Seriously, is anything wrong? Why don't
> you go out anymore?

> LONDON
> I don't know. Maybe I outgrew it.
> Maybe it's time you outgrew it.

> JIE
> Hah! Don't bury me just because you're
> half dead.

Jie heads out. London mumbles sadly.

> LONDON
> I hope I don't bury you.

Courtney and Jo are laughing it up.

 COURTNEY
 Do you smoke?

The laughter ends in an awkward pause.

 JO
 Uh... Do you smoke?

 COURTNEY
 I need to know. It's a deal-breaker
 for me.

 JO
 Deal-breaker that I do smoke or... that
 I don't smoke?

 COURTNEY
 Is that going to change your answer?

 JO
 I guess not, but we were hitting it off
 and I don't want this to blow it.

 COURTNEY
 Better to know now, though, so we don't
 waste our time, don't you think?

 JO
 I don't.

 COURTNEY
 You don't think we'd be wasting our
 time, even if it turns out we're not
 smoking compatible?

 JO
 No. I don't smoke.

 COURTNEY
 Oh... That's... too bad.

 JO
 But... but... I could start.

 COURTNEY
 Thanks, but I was kidding! I *hate*
 smoking!

Courtney and Jo laugh it up again.

Quinn enters, and stops short seeing the sofa Zab is on.

> QUINN
> Did you buy that!?

> ZAB
> The sofa? You like it?

> QUINN
> Are you crazy?

> ZAB
> So you don't like it, then?

> QUINN
> What were you thinking buying it?

> ZAB
> Uh... I was thinking it was 75% off and
> I better buy it before someone else did.
> Do you not like it?

> QUINN
> That's not the point. Why would you
> just buy something like this without
> talking to me first?

> ZAB
> So... you do like it?

A long pause as Quinn looks over the sofa.

> QUINN
> You should have checked with me.

> ZAB
> You do like it. I can see that you like
> it. What's this about?

> QUINN
> You can't just... do stuff like this.

> ZAB
> I can and I did. You wanna buy
> something, you have my blessing. I
> trust you and don't need to *control* you.
> You don't like it. Don't sit on it.

Zab turns away hurt. Quinn sighs, thinking it all over.
After a moment, Quinn sits down on the sofa next to Zab.

Mackenzie approaches Tyrene.

 MACKENZIE
Did you tell Chris about me and Harper?

 TYRENE
I did.

 MACKENZIE
That's it? "I did"? No, "I'm sorry"?
No explanation?

 TYRENE
Why should I be sorry?

 MACKENZIE
Because you had no right.

 TYRENE
It's not about me. Chris had the right
to know.

 MACKENZIE
And who appointed you to be the
instrument of justice?

 TYRENE
Right is right and wrong is wrong.

 MACKENZIE
Could you be any more self-righteous?
Some day, somebody is going to wipe that
smug look off your face.

 TYRENE
You?

 MACKENZIE
You'll never know if it is.

 TYRENE
Threatening me now?

 MACKENZIE
All I said is that someday you'll get
what you deserve.

 TYRENE
I hope so. I do. I hope you get what
you deserve, too.

Reed and P.J. sit quietly, though P.J. is clearly troubled.

> P.J.
> Do you love me?

> REED
> What? Where did that come from?

> P.J.
> Sorry, I know this is not your thing. I
> do. But I need to know.

> REED
> You know how I feel.

> P.J.
> No. Not exactly. Not for sure.

> REED
> Really? Either I've proven it with my
> actions or I haven't.

> P.J.
> Proven what?

> REED
> How I feel about you.

> P.J.
> Which is what?

> REED
> You know.

Reed smiles, making a joke of it. P.J. is not amused.

> P.J.
> I need to hear this from you. If you
> really love me, say it. Do you know how
> unfunny this is?

> REED
> I know. I understand. I do.

> P.J.
> And...

> REED
> I... I'm sorry.

Teegan enters. Val is already seated.

> VAL
> I wanted to talk to you about that
> meeting.

> TEEGAN
> Sure. Went pretty well, right?

> VAL
> Don't contradict me in front of other
> people.

> TEEGAN
> What?

> VAL
> Do you understand your job?

> TEEGAN
> Yeah. I think I do.

> VAL
> I don't think you do. Are you a good
> employee if you don't understand your
> job?

> TEEGAN
> I... I was just playing devil's
> advocate.

> VAL
> Have I given you the impression that I
> asked you in here to debate your
> behavior?

Teegan is stunned.

> VAL
> Have I?

> TEEGAN
> No.

> VAL
> Good.

> TEEGAN
> Do you understand your job?

> VAL
> Yes. Yes. I do now.

25

> SKYE
> I'm thinking about getting a dog.

> PEYTON
> Wow! A dog! You totally should. Dogs
> are the best.

Peyton jumps up, pacing excitedly. Skye stays seated.

> SKYE
> You think? I'm not sure.

> PEYTON
> Yeah! Having a dog there everyday when
> you get home, are you kidding?

> SKYE
> That's a lot of responsibility.

> PEYTON
> Yeah, but think of all the fun.

> SKYE
> And food... not to mention vet bills...

> PEYTON
> Get a puppy. Who doesn't love puppies?

> SKYE
> ...And training... and walking... and
> poop...

> PEYTON
> Dogs are just, like soul companions.

> SKYE
> Am I just trying to avoid my
> relationship issues with this?

> PEYTON
> Can I help you pick it out?

Peyton waits expectantly for Skye to reply. After long
consideration, Skye looks up.

> SKYE
> I think maybe I should hold off.

> PEYTON
> What? Really? Hmmph... How about
> helping me pick out a dog then?

Whitney and Carson approach a door.

> WHITNEY
> Okay, you ready? I want you to make a
> good impression.

> CARSON
> Just a second.

Carson hunches over, and makes a silly face.

> CARSON
> Ready.

> WHITNEY
> Okay, funny. Now can you be serious?

Carson gets overly serious.

> CARSON
> Yes. Of course.

> WHITNEY
> Your hair.

> CARSON
> Oh.

Carson messes it up worse.

> WHITNEY
> C'mon, don't embarrass me.

> CARSON
> I'm just playing. You really think I'm
> going to embarrass you?

> WHITNEY
> Not on purpose.

> CARSON
> Really? What do you think I might do?

> WHITNEY
> I don't know. I don't mean anything,
> I'm just worried about this. Can't you
> tell? It matters. I want them to like
> you... because I like you.

Carson smiles, then takes Whitney's hand. Whitney smiles
back, takes a breath and knocks.

 PIPER
Did you mess with my bike?

 RIO
I just moved it to get at my scooter.

 PIPER
I told you not to touch my stuff.

 RIO
How was I supposed to get my scooter?

 PIPER
Not my problem. Don't touch my stuff,
especially my bike, understand?

 RIO
No, not really. Did I hurt your bike?

 PIPER
Not the point. In fact, I think you're
missing the point.

 RIO
The point is what? You're going to kick
my ass for moving your bike?

 PIPER
Forget about the bike now. This whole
attitude here is the problem.

 RIO
Bring it then. I don't care. You
expect me to back down? Yeah? Well,
you don't know me.

Piper smiles and extends a hand.

 PIPER
Nice. I didn't think you had it, but I
like it. You're for real.

Rio doesn't take the hand, just looks confused. Piper walks
away laughing.

 PIPER
We're gonna get along. Respect.

 RIO
So what, I stand up for myself and you
act like it was all a test? Not buying.

Leighton enters and approaches India.

 LEIGHTON
Don't you care about kids?

 INDIA
Uh... Everybody cares about kids.

 LEIGHTON
Then why don't you take a stand?

 INDIA
A stand? You've taken the bold step of
staking out a pro-child position?

 LEIGHTON
You know what I mean. Why don't you do
something?

 INDIA
Just because I don't wanna do that dumb
run with you, doesn't mean I don't do
anything.

 LEIGHTON
Okay, so what do you do?

 INDIA
I volunteer... at a children's hospital.

Leighton is floored.

 LEIGHTON
Really? I had no idea...

 INDIA
Yeah, twice a week.

 LEIGHTON
Wow. I guess my run is... kind of dumb.

 INDIA
Yeah.

 LEIGHTON
Can I... volunteer with you?

 INDIA
Uh... Your run is not that dumb. Stick
with your run.

 SKYLER
 I'd like to speak with you.

 HANLEY
 Do I know you?

 SKYLER
 I'd just like to ask a few questions.

 HANLEY
 Are you a cop?

 SKYLER
 Reporter.

 HANLEY
 No, then.

Hanley moves away. Skyler pursues.

 SKYLER
 Hear me out.

 HANLEY
 Not interested.

 SKYLER
 I want your side.

 HANLEY
 Forgive me for not thinking you're here
 to help me.

 SKYLER
 I want a story, but I want *your* story.

 HANLEY
 Why?

 SKYLER
 It's who *I* am. I'm for the other guy.
 I am the other guy.

Hanley looks at Skyler a long time.

 HANLEY
 Just a few questions?

 SKYLER
 Just a few.

SEAN
I was hoping to see you here.

AUBREY
Yeah?

SEAN
I've been trying to reach you.

AUBREY
I had to change numbers.

SEAN
I worried maybe you did it to avoid me.

AUBREY
No. That wasn't why.

SEAN
I'm glad. I... I... I'd like to get a
coffee maybe sometime.

AUBREY
I don't know. I'm still pretty raw.
You really hurt me.

SEAN
I know, I know. I handled everything
wrong, I want a chance to tell you.

AUBREY
So did you find yourself?

SEAN
What?

AUBREY
Don't you remember? That's what you
said, you needed time or space or
whatever to find yourself.

SEAN
I think I did, and I figured out how I
feel about you. Give me a chance to
tell you.

Aubrey thinks about it, sighs.

AUBREY
I don't think so. I'm glad you found
yourself, but you lost me.

 RILEY
 Can I borrow five bucks?

A.J. sighs deep and looks daggers at Riley.

 RILEY
 C'mon let's not make a whole thing out
 of this. It's only five bucks.

A.J. relents and starts to pull out money.

 RILEY
 Maybe we could just make it twenty?

 A.J.
 C'mon this is ridiculous. How many
 times do we have to go through this?

 RILEY
 If twenty's too much, I'm happy with
 ten.

 A.J.
 You can't keep living like this. You've
 got to support yourself.

 RILEY
 I'm working on it. You know I'm working
 on it. Meanwhile I need ten lousy bucks
 to get by. You've got it.

 A.J.
 Ten today, twenty tomorrow, five more
 that day after that.

 RILEY
 I promise. I won't hit you up tomorrow,
 just hook me up today. You don't want
 to see me go hungry do you?

 A.J.
 No, so I'll buy you a sandwich.

 RILEY
 Okay, sandwich and five bucks?

A.J. sighs deeply, pulls out the money.

 RILEY
 I knew I could count on you.

 SAGE
It's great to see you. I didn't know
you were going to be here.

 RYO
I didn't know you would be here either.

 SAGE
I'm glad, though. I know everyone
always says that thing about wanting to
stay friends, but I really meant it.

 RYO
That's nice.

 SAGE
I'm serious. I miss you. We had so
much fun. We were such great friends.

 RYO
We were. It was great, but it's over.

 SAGE
It doesn't have to be. Let's do
something fun, a movie. It'll be nice.

 RYO
I'm really not interested.

 SAGE
Wow. I thought things ended a lot
better than this for us.

 RYO
They did end well, but since then
I've... rethought things.

 SAGE
That's too bad. I think you're making a
mistake. We can still be close.

 RYO
Look, things ended well with us because
I didn't know about you and Taylor at
the time. Now I do.

Sage backs away awkwardly.

 SAGE
Oh... I see now... Well, I guess I
won't press you on the friends thing
then.

 SHAYNE
 Get you a soda?

 RED
 Nah.

 SHAYNE
 You sure?

 RED
 Yeah. I'm good.

Shayne walks out. After a moment, Shayne returns drinking a
soda.

 RED
 Ooh, can I get a sip?

 SHAYNE
 What? No!

 RED
 Just a sip.

 SHAYNE
 I offered to get you a soda.

 RED
 I don't want a soda. I just want a sip.

 SHAYNE
 Do you do this stuff just to annoy me?
 I don't want to share my soda. You want
 your own soda or not? I can still go
 get one for you.

 RED
 No. Sorry. I'm good.

Shayne sits sipping the soda. Red watches.

 RED
 Really could go for a sip, though.

 SHAYNE
 Are you kidding me!? Here!

Shayne hands the soda to Red and storm out. After a moment,
Red takes a drink and sets it down.

Samra pulls up limping while jogging, clearly in pain. D.J.
jogs up and stops.

 D.J.
 Get your weight off it.

 SAMRA
 Who are you?

With a hand from D.J., Samra eases to the ground.

 D.J.
 D.J. Let me see.

Samra lies back as D.J gently manipulates the injured ankle.

 D.J.
 If it moves like this without too much
 pain, it's most likely just a sprain.
 That's what you get for not stretching.

 SAMRA
 How do you know that?

 D.J.
 Pre-med.

 SAMRA
 No. How do you know I didn't stretch?

An awkward moment. Samra pulls away from D.J., trying to
stand back up.

 D.J.
 Lucky guess, so what?

D.J. tries to support Samra, who hops away grimacing.

 SAMRA
 I don't think so.

 D.J.
 I'm not a stalker or something. I've
 just seen you jogging before. You never
 stretch. I noticed you, okay? You're
 cute. Sorry. Is that too creepy?

Samra considers a moment then hops over and leans on D.J.'s
shoulder.

 BROOKS
 Gimme a kiss.

Brooks moves in on Shea but gets straight-armed.

 SHEA
 No. Please.

 BROOKS
 What? What's wrong?

 SHEA
 Nothing. Just not now, okay?

 BROOKS
 What's wrong now? There was no problem
 last night.

 SHEA
 Last night we were alone.

Brooks looks around.

 BROOKS
 Not in front of these people then?

 SHEA
 Yeah, sorry.

 BROOKS
 Are you embarrassed?

 SHEA
 Yeah.

 BROOKS
 ...By me?

 SHEA
 No! I'm sorry, it's not that at all.
 I've just never been comfortable with
 PDAs. I didn't mean to hurt you.

 BROOKS
 Oh, okay... Kiss and make-up then?

Brooks moves in, but Shea straight-arms again.

 BROOKS
 Totally kidding! Just trying to show
 I'm okay with it.

 MARKIE
 Give it a try.

 ZELLER
 I don't want to.

 MARKIE
 We had this discussion before. You
 agreed you needed to try more new
 things.

 ZELLER
 Okay, that doesn't mean I have to try
 every new thing.

 MARKIE
 Then when are you going to start? What
 new things have you tried?

 ZELLER
 I will... I will, but why this? Why
 now?

 MARKIE
 You have to start somewhere. Why not
 here?

 ZELLER
 I'm not comfortable with this.

 MARKIE
 You're not comfortable with anything
 new. That's kind of the point here.

 ZELLER
 I know. You're right. Please, be
 patient with me.

 MARKIE
 I will, I will, but show me something.

 ZELLER
 Okay.

 MARKIE
 You're ready then?

 ZELLER
 Not yet.

Markie jumps up and leaves without a word. Zeller is more
relieved than regretful.

Kai approaches Vickers.

> VICKERS
> What are you doing here?

> KAI
> Give me one more chance.

> VICKERS
> You must think I'm stupid.

> KAI
> I don't, but... I hope you still love
> me.

> VICKERS
> However I feel about you, it couldn't
> make me stupid enough to give you
> another chance.

> KAI
> What *could* make you give me another
> chance?

Vickers considers it for a moment.

> VICKERS
> Look, I'm flattered by all this, I
> suppose, but it's just too late.

> KAI
> It's not too late if you still love me.

> VICKERS
> I don't know how I feel anymore.

> KAI
> What does your heart say?

Vickers considers for a long moment.

> VICKERS
> My heart is still broken... from you
> cheating on me.

> KAI
> I can only apologize so many times.

> VICKERS
> Good, maybe you're about done and will
> leave me alone.

Darcy and Evelyn sit down across from each other.

> DARCY
> I can't even tell you what I thought
> when I saw it was you hiring for this
> job—literally the best thing that's
> happened to me in months.

> EVELYN
> Good to see you too.

> DARCY
> Yeah, exactly. Good to see you.

> EVELYN
> Well let's get going, then.

> DARCY
> Sure. We need to do some paperwork?

> EVELYN
> Yes, but let's do the interview first.

> DARCY
> Interview?

> EVELYN
> Yes, part of the application process.

> DARCY
> But... You know me already.

> EVELYN
> Still, there's a process that needs to
> be followed.

> DARCY
> You know what the answers are supposed
> to be, just fill them in.

> EVELYN
> I think it's best if I ask the questions
> and you actually answer.

> DARCY
> Oh Lord, I see now... You're not going
> to give me this job, are you?

> EVELYN
> *Give* you the job? Never did understand
> how things work, did you?

Shuang hustles in with a suitcase and looks around the room one
last time. Rain looks up.

> SHUANG
> Okay, think I got everything, hope I do
> anyway, running late, gotta go!

> RAIN
> I won't be here when you get back

> SHUANG
> Ha, ha, not funny right now.

> RAIN
> I'm not joking. You know I'm not.

Shuang stares at Rain, letting it sink in.

> SHUANG
> No. You wouldn't do this now. Would
> you?

> RAIN
> This is exactly when I'm doing this.

> SHUANG
> Are you kidding me!? I'm already
> fifteen minutes late and you know how
> important this is to me!

> RAIN
> I do and you should go.

> SHUANG
> You're doing this now on purpose, so you
> don't have to deal with it!

> RAIN
> Hey, I didn't have to tell you at all.

> SHUANG
> Oh? Well thanks, I guess.

> RAIN
> You're welcome.

> SHUANG
> Okay, I got it. I'll tell you this,
> though, you will not ruin this for me

Shuang storms out. Rain leans back, smiling smugly.

 DREW
 Help me clean up.

 MALI
 What? The place *is* clean.

 DREW
 It is *not* clean. You're being lazy.

 MALI
 You being obsessive-compulsive about
 cleaning, doesn't make me lazy.

 DREW
 Obsessive-compulsive? Really? We
 haven't cleaned in over a week.

 MALI
 A week! Oh, my God! How can we live
 like this? Like animals!?

 DREW
 So what... we should clean once a month?
 Twice a year?

 MALI
 How about if we clean when the place
 needs cleaning?

 DREW
 Clearly we have a different idea of what
 clean means.

 MALI
 Clearly.

 DREW
 How about a compromise?

 MALI
 Yeah, you clean when you think we need
 to clean and I'll clean when I think we
 need to clean. Everybody gets what they
 want.

 DREW
 You're cute, but see how this works out
 for you.

Drew's sudden coldness gets Mali concerned for the first time.

Griel and Rory are having a good time.

> RORY
> Don't think just because you bought me a
> couple drinks, you're getting anything
> in return.

> GRIEL
> Ha, ha. Like what, help with my taxes?

> RORY
> You know what I mean.

> GRIEL
> I guess. But with you, I'll stick with
> the tax help.

> RORY
> That... That's just mean.

> GRIEL
> You're the one who insinuated I was some
> kind of creeper.

> RORY
> No... I... It was a joke.

> GRIEL
> So was the tax thing.

Griel and Rory both rethink the situation.

> RORY
> So, then are you interested in more that
> just—

> GRIEL
> Let's just drop this, okay?

> RORY
> Tell me why you bought me the drinks
> then.

> GRIEL
> I... I do need help with my taxes.

Rory leaves.

> RORY
> Start by writing me off.

Hayden paces around. Lex sits, head in hands.

> HAYDEN
> How could you? I thought you were my
> friend.

> LEX
> I didn't want it to happen. It just...
> happened.

> HAYDEN
> How does that make it better?

> LEX
> It doesn't, but it's true. I didn't
> mean to hurt you. I'm sorry.

> HAYDEN
> You knew I was in love.

> LEX
> I did, but you hadn't done anything
> about it.

> HAYDEN
> Not yet. Why does that matter?

> LEX
> It doesn't make it okay, but it's not
> like you two were going out.

> HAYDEN
> Now we're not for sure.

> LEX
> But were you ever, honestly?

> HAYDEN
> I might have.

> LEX
> Honestly?

> HAYDEN
> Probably not.

Hayden walks out feeling even worse.

> LEX
> I'm still really sorry.

 CONG
Do you know how I feel about you?

 ADRIAN
I think so. I'm pretty fond of you,
myself.

 CONG
I think I feel stronger than that.

 ADRIAN
Well, let's not make a competition out
of it.

 CONG
But I want you to know how I feel.

 ADRIAN
I've got the idea. Let's not rush
anything.

 CONG
What do you mean rush?

 ADRIAN
I mean... Let's give our feelings time
to grow and see where it goes...

 CONG
My feelings have grown. Are you saying
yours haven't?

 ADRIAN
They have, they have, but I don't think
as fast as yours. Don't rush me. Let's
let things develop... naturally.

 CONG
I'm okay with that, but it doesn't
change how I feel about you. I love-

 ADRIAN
NO! Don't put that pressure on me.
It's too early. Haven't you been
listening to me? Give this some time.

Adrian flees the room.

 CONG
I... I'm sorry. I didn't mean to...
I... hope I didn't... blow this.

 DALE
How'd it go?

 J.B.
Good... I think.

 DALE
What do you mean? Were you awkward at
the interview or something?

 J.B.
You think I would be awkward?

 DALE
No. You said something went wrong.

 J.B.
I didn't say anything went wrong.

 DALE
Okay, not "went wrong," didn't go right.

 J.B.
I didn't say anything like that. What
makes you think it didn't go well?

 DALE
I don't think that. I'm sure it went
well. I must have just misunderstood.

Long awkward pause.

 J.B.
It went okay. Actually, it mostly went
really well. There was one question in
the interview, though.

 DALE
I knew it.

 J.B.
What do you mean you knew it?

 DALE
There was something in your tone. I
could tell something went wrong.

 J.B.
Nothing went wrong! Why are you so
certain I would fail!?

Sloane enters and sees Darnell

> SLOANE
> Oh, hey, how'd the date go?

> DARNELL
> C.J. is nice enough.

> SLOANE
> So? You had stuff in common, right?
> C.J. is into art and movies.

> DARNELL
> We had a nice chat. We did actually
> talk a lot about movies.

> SLOANE
> That's good. So you going out again?

> DARNELL
> You know... to go out... people
> should... kind of be the same level of
> attractiveness.

> SLOANE
> What are you saying? C.J. is ugly?

> DARNELL
> Not exactly.

> SLOANE
> You know I went out with C.J., right?

> DARNELL
> That's cool for you.

> SLOANE
> What!?

> DARNELL
> I didn't mean that... I guess... you're
> a less superficial person than me.

> SLOANE
> Or less of a douchebag, maybe. See if I
> try to fix you up again.

Sloane leaves angry. Darnell mumbles.

> DARNELL
> Fine, keep your ugly exes to yourself.

 FARLEY
 Hey! How are you?

Farley and Jer greet each other warmly.

 JER
 I'm really good. It's so nice to see
 you. I've... really missed you.

 FARLEY
 Great to see you too. If you don't mind
 me asking... how'd the rehab go?

 JER
 I can't mind you asking. You should
 know, I'd have never rehabbed if not for
 you. I went in right after that night.

 FARLEY
 What night?

 JER
 The one where we got really hammered.

 FARLEY
 Me and you? When was this?

 JER
 About... six-seven weeks ago. We were
 at Hillary's party and then hit some
 bars.

 FARLEY
 Really? I seriously don't remember
 this. Sounds like we had some fun.

 JER
 I'm sure we did, but I woke up in a
 puddle in an alley. Had to go to the
 hospital for hypothermia.

 FARLEY
 Oh, my God. Really? I feel awful. We
 were out together and you ended up in an
 alley? I never even knew. I don't even
 remember. I'm so sorry.

 JER
 Don't be sorry. It saved my life. I'm
 just sorry something like that hasn't
 happened to you.

 ZEE
 I think this was a mistake.

 BOBBY
 Too late to get cold feet now.

Zee gives Bobby a long, examining look.

 ZEE
 You're really okay with this?

 BOBBY
 Yes.

 ZEE
 I... I'm...

 BOBBY
 What? Obviously you were down with it
 or you wouldn't have done it, so what's
 up now?

 ZEE
 You don't have to get angry. I'm just
 trying to figure things out.

 BOBBY
 I'm not angry. I just don't get you.

 ZEE
 And you try so hard, don't you?

 BOBBY
 Did I do something wrong?

Bobby waits for an answer.

 BOBBY
 Seriously. You're acting like I did
 something wrong here.

 ZEE
 Can you really not understand why this
 is a big deal to me and I need to sort
 out how I feel about it?

 BOBBY
 No.

 ZEE
 Huge mistake...

Chile and Cruz walk in together.

 CHILE
 This is where we're supposed to sleep?

 CRUZ
 I guess.

 CHILE
 There's only one bed.

Cruz sits on it, bouncing.

 CRUZ
 Nice bed though.

 CHILE
 I am not sleeping with you.

 CRUZ
 Ouch.

 CHILE
 Nothing personal.

 CRUZ
 Yeah. Well, you can sleep on the floor.

 CHILE
 I'm not sleeping on the floor. You can
 sleep on the floor.

 CRUZ
 I'm not the one that doesn't want to
 sleep in the bed.

 CHILE
 I want to sleep in the bed.

 CRUZ
 You just don't want to share it.

 CHILE
 Okay. I guess your right, I'm the one
 has to sleep on the floor.

 CRUZ
 You don't have to...

Cruz pats the bed, invitingly. Chile looks at the floor a
long moment, then sits next to Cruz on the bed. Cruz smiles.

Tristan and Addie sit knee to knee. Addie keeps Tristan, full
of nervous energy, from standing.

> TRISTAN
> I can't do it. I can't stop.

> ADDIE
> You already stopped.

> TRISTAN
> Ha, ha! A few days. Big deal.

> ADDIE
> It's a start. You're doing great.

> TRISTAN
> No. I'm not doing great. I'm breaking
> down. I'm not making it.

> ADDIE
> I'm here now, though. We can do this.

> TRISTAN
> Really? We? Why?

> ADDIE
> You need help. You're a good person.

> TRISTAN
> And...

Addie looks confused, uneasy.

> ADDIE
> And what?

> TRISTAN
> And you think this will go somewhere...
> with us.

Addie hesitates.

> ADDIE
> I'm sorry. I can leave. I...

> TRISTAN
> No. I'm glad you're here. I'm glad...
> about everything.

Avery, overwhelmed with excitement, approaches Jai.

> AVERY
> Thank you, thank you! Oh, my God! I'm
> so excited! I could kiss you!

> JAI
> What? Please don't. Not cool.

Jai backs away.

> AVERY
> That's just an expression.

> JAI
> Good. I'm glad.

All the excitement ebbs from Avery.

> AVERY
> Really?

> JAI
> What?

> AVERY
> This is such a problem? So disgusting
> is the mere mention of my kiss that you
> have to completely crap on my moment?

> JAI
> I just thought... I guess, yeah, I
> didn't want you to kiss me. I didn't
> think you would take it like this.

> AVERY
> You're right. I shouldn't be taking it
> like this. You're right. What's wrong
> with me? God...

Avery slumps. Jai feels bad, tries to comfort.

> JAI
> Look, it's no big deal. It's my fault.
> I'm sorry. Really. Enjoy your moment.
> I am excited for you.

Avery smiles, goes in for a hug. JAI backs away.

> JAI
> No. No hugging either.

 FINLEY
I think I'm gonna get my driver's
license.

 ALEX
You think that's a good idea?

 FINLEY
What do you mean?

 ALEX
It's a dangerous thing, driving.

 FINLEY
Plenty of people still do it.

 ALEX
Doesn't mean everybody should. Probably
a lot of people shouldn't be driving.

Finley becomes suspicious.

 FINLEY
So *I* shouldn't be driving.

Alex doesn't respond, just kind of shrugs.

 FINLEY
Okay. Tell me. Why shouldn't I be
driving?

 ALEX
Just ask yourself, am I the right sort
of person for that responsibility?

 FINLEY
Okay, got it, then help me. What is the
right sort of person?

 ALEX
You know, someone with focus,
concentration. Someone who's not easily
distracted or too emotional.

 FINLEY
Really? That's what you think of me?

Finley storms away.

 ALEX
I didn't say anything about you!

 LERNER
If you see Adin or Desi, tell them I'm
still out of town.

 IMAN
You want me to lie?

 LERNER
If you want to put it that way.

 IMAN
I don't lie.

 LERNER
Everybody lies.

 IMAN
I don't.

Lerner considers a moment.

 LERNER
Okay, pretend I'm Brett and I come up
and say to you, "Do you think I'm fat?"

 IMAN
I think you're beautiful, Brett.

 LERNER
But am I fat?

 IMAN
We could all be in better shape.

 LERNER
Not other people, me. Am I fat?

 IMAN
Against what standard? What makes
someone fat?

 LERNER
Okay. I got an idea. If Adin or
Desi ask about me, just don't tell them
I'm back. That you can do, right?

 IMAN
I'm not sure...

 LERNER
Oh, believe me, you can do it.

CHANDLER
I'm Chandler from the dating site.

Ulee is confused, doesn't know how to respond.

CHANDLER
I know, I don't look like I do on the
internet.

ULEE
You sure don't.

CHANDLER
I hope you're not disappointed.

ULEE
I'm confused.

CHANDLER
I just don't trust the internet. It's
creepy putting your picture on there.

ULEE
Well you're not exactly doing your part
to make the internet trustworthy

CHANDLER
Yeah. You're right.

ULEE
So, this way you can make dates and
sometimes see the person and sneak away?

CHANDLER
Not sometimes... pretty much every time.

ULEE
Wow. Sucks for all them, but I guess...
I should be flattered?

CHANDLER
You seemed different... Really...

ULEE
I'm not...

CHANDLER
What?

ULEE
I'm not disappointed.

 JAMIE
 I got a ticket.

 DAKOTA
 Like a traffic ticket? Bummer.

 JAMIE
 Got it in the mail.

 DAKOTA
 Yeah?

 JAMIE
 Yeah. One of those photo red-light
 tickets.

 DAKOTA
 Really?

 JAMIE
 Thing is... wasn't me driving.

 DAKOTA
 I see where you're going now. If it was
 me, of course, I'll pay for it.

 JAMIE
 Oh, you will, but what I want to know is
 what you were doing driving my car.

 DAKOTA
 You loaned it to me, don't you remember?

 JAMIE
 I loaned it to you two months ago, but
 not last month.

 DAKOTA
 It wasn't that long ago.

 JAMIE
 There's a date on the ticket. It was
 when I was in New York, and I definitely
 didn't loan you the car when I was in
 New York.

 DAKOTA
 The car's fine. I'll pay the ticket.
 What's the big deal?

Jamie leaves without another word.

Jude enters, Ronde sits, arms crossed.

 RONDE
 Where were you?

 JUDE
 Sorry. I got held up.

 RONDE
 How convenient that worked out.

 JUDE
 It's not like that. I got held up.

 RONDE
 That's why you called? That's why you
 texted?

 JUDE
 Sorry. Okay? What did the doctor say?

 RONDE
 Please. Don't try to act concerned now.

 JUDE
 Okay. I'm not really concerned anyway,
 so don't tell me. Sorry I asked.

Jude starts to leave.

 RONDE
 Really? You're going to leave?

 JUDE
 You won't tell me anything!

 RONDE
 I'm fine, okay!

 JUDE
 That's what I told you. You didn't
 really need me there at all, did you?

 RONDE
 Are you kidding? Do you understand what
 that moment was like before I knew that?

 JUDE
 Yes, I do understand that moment because
 you have five of them *every damn day*.

 RONI
 I haven't been totally honest with you.

 TANNER
 Ooh. That's never good to hear.

 RONI
 Yeah. It's probably not that big a
 deal, but I think we're at this place...

 TANNER
 Alright, already. What is it?

 RONI
 I want to have kids.

 TANNER
 What?

 RONI
 Not right now or anything. It's just
 that I had said before I didn't want
 kids and that wasn't true.

 TANNER
 Why'd you say it then?

 RONI
 I thought it would make things easier.
 Take some sort of pressure off.

 TANNER
 And you're not worried about that now?

 RONI
 No, I'm still really worried about that,
 but at this point, I think it's more
 important to be totally honest with you.

Tanner smiles reassuringly and Roni visibly relaxes.

 TANNER
 Well, stop worrying. I'm glad you want
 to be honest. I should be honest too...
 Ever hear of sexual reassignment
 surgery?

Roni looks up in shock.

 TANNER
 Kidding!

 TRAGER
 I heard something about you.

Athol is distracted and doesn't look up.

 TRAGER
 It is not good.

 ATHOL
 What?

 TRAGER
 I heard you have an... STD.

 ATHOL
 What!?

 TRAGER
 Yeah.

 ATHOL
 Why would you think that!?

 TRAGER
 Wait. When did I say I thought that?
 I'm just telling you what I heard.

 ATHOL
 Okay, but when you heard it, you told
 whoever said it it wasn't true, right?

 TRAGER
 How do I know if it's true or not?

 ATHOL
 So you do believe it?

 TRAGER
 What? I didn't say I believed it, but
 I'm in no position to deny it either.

 ATHOL
 What sort of waffling crap is that? Are
 you my friend or not?

 TRAGER
 Yeah, I am your friend, but I'm not your
 damn press agent. You're welcome for
 giving you the heads up about this.

Trager walks away angry.

Shane looks in a mirror, thinking.

 SHANE
 I think I'm gonna dye my hair.

 ASTE
 Why do that? I like your hair color.

 SHANE
 Thanks, but I need a change.

 ASTE
 How is that a change for *you*? You can't
 see it unless you look in a mirror.

 SHANE
 Yeah, well I plan on spending a lot of
 time looking in mirrors.

 ASTE
 I know you're joking, but isn't this
 just the most vain, superficial thing
 you could spend your time and money on.

 SHANE
 It's not plastic surgery. It's like
 buying a new outfit or something.

 ASTE
 Is it? Clothes are clothes, but
 changing your hair color is showing
 dissatisfaction with the way you are.

 SHANE
 So then does getting a haircut or
 shaving mean you're not happy with the
 way you are? What about bathing?

 ASTE
 There's grooming or whatever and then
 there's *changing*.

 SHANE
 Ah, so you admit it's a change then?

 ASTE
 Oh... You're a smart one. Remind me
 not to tangle with you.

 SHANE
 You sure? I kind of like tangling.

Ashton walks up next to Piney without making eye contact.

> ASHTON
>
> I know everything.

> PINEY
>
> Sorry?

> ASHTON
>
> I know *everything*.

> PINEY
>
> I'm sure I don't know what you're
> talking about.

> ASHTON
>
> I'm sure you do and I'm sure you know
> who I am too.

> PINEY
>
> I'm just going to ignore you.

> ASHTON
>
> I want you to know you're not slick.
> You're not getting away with anything.

> PINEY
>
> Okay. You've made whatever crazy point
> you were trying to make. Will you just
> leave me alone now?

> ASHTON
>
> No. I also want you to know that what
> you're doing... People are getting
> hurt.

> PINEY
>
> You win, I guess. I'm leaving.

> ASHTON
>
> There are victims. It's not all fun.
> People get hurt.

Piney starts to go, but turns to Ashton first.

> PINEY
>
> You think there's no blame for you in
> all this?

> ASHTON
>
> Oh, I know. I know *everything*.

Ellery approaches Blythe.

> ELLERY
> Hey, don't I know you from somewhere?

> BLYTHE
> Really? That's the best you've got?

> ELLERY
> Oh... you think that's a line, right?

> BLYTHE
> It's not a line?

> ELLERY
> I see where you might think that's a
> line. It's usually a line, but I think
> I really know you from somewhere.

> BLYTHE
> Yeah, yeah.

> ELLERY
> Seriously.

> BLYTHE
> So you're saying if I offered you my
> phone number right now, you wouldn't
> take it?

> ELLERY
> Well... That's not fair. That's a
> different issue.

> BLYTHE
> Yeah... That's what I thought.

> ELLERY
> Okay, fine, sorry I bothered you.

> BLYTHE
> Better luck next time.

> ELLERY
> Oh! I know, it was high school. Taft
> High School. You were in the band.

Ellery has already walked away by the time Blythe reacts.

> BLYTHE
> Wait... sorry!

Jun finishes reading something. Fernie waits expectantly.

> FERNIE
> So, what'd you think?

> JUN
> I liked it. I did.

> FERNIE
> And...

> JUN
> I really like it, I told you, but I'm
> the wrong person if you want criticism.

> FERNIE
> Oh, okay... What... did you like about
> it?

> JUN
> It was just a good story. Like I said,
> I'm the wrong person if you want
> specifics.

> FERNIE
> Alright, alright.

> JUN
> I'm sorry, I know you want more.

> FERNIE
> It's alright. I just know you had a lot
> to say about Tai's story.

> JUN
> Tai's different.

> FERNIE
> How is Tai different? You mean Tai's a
> good writer.

> JUN
> No, I mean Tai won't leap to bad
> conclusions about stuff. Tai is good
> with criticism.

> FERNIE
> Wow. So what are you implying?

> JUN
> I liked it. That's all I'm saying.

 SHANNON
Who do you love?

 DEEZE
You, dear.

 SHANNON
How much?

 DEEZE
A lot.

 SHANNON
How much is that?

 DEEZE
A ton?

 SHANNON
Awww, I love you a ton too.

 DEEZE
Yeah, glad we're on the same page.

 SHANNON
Are you being sarcastic?

 DEEZE
No. I really do love you.

 SHANNON
A ton?

 DEEZE
Look, I love you and all and I don't
mind telling you, but all this "how
much" stuff does get old for me. Aren't
we more secure in our love than that?

 SHANNON
Yeah. I guess. Okay. I'm sorry.

Shannon slumps away, Deeze sighs.

 DEEZE
Hey, I love you... I do... I love
you... a ton.

Shannon smiles and runs back to Deeze.

 DION
 Don't forget, I want you to go to the
 doctors with me.

Mo tries to act casual, but Dion is wise to the act.

 MO
 When was that again?

 DION
 Don't play this game. We've been over
 this.

 MO
 Yeah, but I've got some other things
 going now.

 DION
 You can't do this. I need you there.

 MO
 You're going to be fine. Stop making
 such a deal out of it.

 DION
 I don't know that. You can't know that.
 Why are you trying to avoid this?

 MO
 I've told you how I feel about doctors.

 DION
 This isn't about you. I'm the one who
 should be freaked out.

 MO
 I'm sorry. Ask me to do something else
 for you.

 DION
 Something else?

 MO
 I'd do this if I could. I can't.

 DION
 It clearly just doesn't mean enough to
 you.

Dion storms out. Mo remains, feeling guilty.

Zhang ushers Rennie in.

> ZHANG
>
> I wanted to talk to you.

> RENNIE
>
> Yeah, I know. I'm here, aren't I?

> ZHANG
>
> Yes, I appreciate it, thanks. It's good to see you.

> RENNIE
>
> Yes, nice to see you too, so what's up?

> ZHANG
>
> I just wanted to talk.

> RENNIE
>
> Yes, you said that.

> ZHANG
>
> Are you angry?

> RENNIE
>
> No, sorry, I'm not angry, I just want to know what this is all about.

> ZHANG
>
> I wanted to tell you that, well... basically... I still love you.

> RENNIE
>
> Uh... Haven't we had this talk already?

> ZHANG
>
> Being apart now for a while, I've had time to think... You've had time to think...

> RENNIE
>
> Yes. And I don't think any differently, okay?

> ZHANG
>
> Okay, no need to be cruel.

> RENNIE
>
> I'm not being cruel. We broke up. It's over. I still care about you, but I'm telling you, you need to move on.

 KENDALL
Oh, my God, I'm so nervous.

 FALLON
Relax, you're going to do great.

 KENDALL
I think I'm gonna puke.

 FALLON
Breathe. Concentrate on breathing.

 KENDALL
Yeah, breathing.

 FALLON
In. Out. In. Out. In. Out.

Kendall breathes along with Fallon, calming down.

 KENDALL
I'm calm. I'm thinking straight, and
I'm realizing I shouldn't be here. I
should go. I'm going.

 FALLON
No, you're going to be fine. You're
going to be great. Just relax.

 KENDALL
Why? Why put myself through this?

Kendall stares at Fallon demanding an answer.

 FALLON
If you don't, you'll regret it. Believe
me. Don't let yourself down. You'll
feel better for a moment, but feel bad
about it for a *long* time.

 KENDALL
Thanks. I... I don't know what to say.

 FALLON
Yeah, well, unfortunately, I speak from
experience. Now, you got this?

Fallon puts a hand on Kendall's shoulder. They make eye
contact for a long moment. Kendall suddenly convulses holding
back vomit and then runs off. Fallon sighs.

 CHASE
 Can I tell you something?

 SOLIS
 Sure.

 CHASE
 I think I'm in love.

 SOLIS
 Really? With who?

 CHASE
 Doesn't really matter. I don't think I
 can tell them.

 SOLIS
 Tell who?

 CHASE
 You think I should tell them?

 SOLIS
 Tell who?

 CHASE
 Love is pretty strong. It's probably
 just a crush.

 SOLIS
 On who?

Solis grabs Chase by the shoulders.

 SOLIS
 Look at me. Do not say another word
 until you tell me who it is.

 CHASE
 It's you.

They stare awkwardly for a long time. Then Solis slowly let's
go of Chase's shoulder.

 CHASE
 Well? Should I have told you?

 SOLIS
 No.

 ARON
You told me you saw Kim with P.J.

 JIANG
Yeah.

 ARON
You knew I would tell Dale.

 JIANG
How would I know who you'd tell?

 ARON
Oh, you knew.

 JIANG
Okay, where you going with this?

 ARON
You wanted Dale to think Kim was
cheating. I think you set me up. I
think you used me.

 JIANG
That's ridiculous.

 ARON
Yeah? Tell me again where and when you
saw Kim and P.J. together.

 JIANG
I told you, I saw them at the mall on
Saturday.

 ARON
Yeah. I found out Kim was out of town
last weekend.

Jiang reconsiders.

 JIANG
I thought it was them.

 ARON
Yeah. Not really buying that.

 JIANG
Would it matter if I said I was sorry?

Aron walks away without a word. Jiang shrugs it off.

 DANNI
 You're making a mistake.

 MEL
 What?

 DANNI
 I'm just not sure it'll work out between
 you two.

 MEL
 Really? You can't be happy for me?

 DANNI
 It's not that. I just don't want to see
 you get hurt.

 MEL
 You're the one hurting me right now.

 DANNI
 You know that's not what I'm trying to
 do.

 MEL
 I don't know that. Are you jealous?

 DANNI
 No.

 MEL
 Is this about you and me?

Danni hesitates too much.

 DANNI
 No.

 MEL
 Because this is it. If you've got
 something to say, say it now.

Danni can't look Mel in the eye. Mel steps closer.

 MEL
 Please. I want you to say it.

 DANNI
 I... I... I'm happy for you.

Mel walks away crushed.

T.J. approaches Morgan awkwardly.

> MORGAN
> Was that sales report okay?

> T.J.
> Huh? Oh, I... haven't looked at it yet.

> MORGAN
> I think it's good. There anything else?

> T.J.
> You... like working here?

> MORGAN
> So far, it's alright. Yeah, I like it.

> T.J.
> You like everybody that works here.

> MORGAN
> Yeah, pretty much.

> T.J.
> Good to have you here, too.

> MORGAN
> Thanks...

> T.J.
> I wanted to ask you...

Huge pause. Morgan finally sees where this is going.

> MORGAN
> You know... I just went through an ugly
> break up.

> T.J.
> Oh. I didn't—

> MORGAN
> You couldn't, it just happened, but I'm
> going to just chill for a while, okay?

> T.J.
> Of course. I wasn't... Well I guess I
> was... but not now, of course... sorry.

After T.J. backs away, Morgan breathes a sigh of relief.

> SUTTER
> We're supposed to be working on this
> project together.

> PING
> We are, aren't we?

> SUTTER
> I guess what I'm saying is that we are
> supposed to be sharing the work.

> PING
> Am I not doing enough of the work?

> SUTTER
> You're not. I'm afraid I'm doing most
> of it.

> PING
> I'm sorry. I really am doing my best.

> SUTTER
> See, that's the thing. I've been
> thinking that, but now I'm not so sure.

> PING
> But I can't help it that you're smarter
> and faster than I am.

> SUTTER
> Thanks, I'm flattered, but are you
> really trying your hardest?

> PING
> Yes, but I'll try even harder.

> SUTTER
> Yeah. You probably should, because I
> talked to Hollis. Hollis says your work
> is actually stellar, but only when
> you're properly motivated.

> PING
> Really? I don't understand why Hollis
> would say that, but I will try harder.

Ping smiles earnestly, but Sutter stares coldly.

> SUTTER
> Yes. You will.

 ARIEL
 Can we talk?

 R.J.
 Sure. Something wrong?

 ARIEL
 Oh, no. I just... I guess I want us to
 be closer.

Ariel feels awkward and R.J.'s slow response doesn't help.

 R.J.
 Closer?

 ARIEL
 If we're both going to be in Robin's
 life the way we are, I think it'd be
 nice if we... You know...

 R.J.
 I got no problem with you.

 ARIEL
 I know, but maybe we can be friends.

 R.J.
 That comes in time, right?

 ARIEL
 Yeah, but we could make more of an
 effort, don't you think?

 R.J.
 An effort?

 ARIEL
 Sure. We could do some things, friend
 things, have some fun.

Long, awkward pause.

 R.J.
 I appreciate your intention here, but
 I'd be happier taking it slower.

 ARIEL
 Oh, yeah, of course. No hurry.

Ariel and R.J. both strain to smile.

 B.D.
 Let's go. You heading home? I'll go
 with.

 MANK
 I'm good.

B.D. stares a moment, confused.

 B.D.
 They're closing. You can't stay.

 MANK
 I'm not in a hurry.

 B.D.
 Are you not heading home?

 MANK
 I don't know yet.

 B.D.
 Is something wrong?

 MANK
 No.

 B.D.
 Then what's up?

 MANK
 Nothing's up.

 B.D.
 Let's go then.

 MANK
 I just don't want to go with *you*, okay?

 B.D.
 What!? I was going to walk home with
 you. Not take you to the damn prom!

 MANK
 Please. You're embarrassing me.

 B.D.
 I'm embarrassing you!? I... I...
 You're right. I'm sorry. I get it.

B.D. leaves ashamed. Mank immediately regrets it.

> PURCELL
> I'm gonna kill you!

Spencer is startled, jumps up. They circle each other.

> SPENCER
> Calm down. What's this about? Talk to
> me.

> PURCELL
> Don't try to be slick. You're not
> talking your way out of this.

> SPENCER
> Out of what?

> PURCELL
> Me killing you.

> SPENCER
> No, I mean, what is it that you think I
> did?

> PURCELL
> You and Morgan. I know all about it.

> SPENCER
> Morgan? Who the heck is Morgan? Who
> told you what exactly?

> PURCELL
> Hah! You think that's going to work?

> SPENCER
> Just wait, are you a hundred percent
> sure it's me you're looking for? I
> swear I don't even know any Morgans.

> PURCELL
> Morgan... Miller?

Purcell stops. Spencer shrugs, nods "no". Purcell sighs.

> PURCELL
> Okay. I'll go double-check, but if I
> find out it was you...

> SPENCER
> Yes, yes, you'll kill me.

Purcell trudges away. Spencer smiles.

Dylan runs in. Arie barely looks up.

 DYLAN
I'm ready!

 ARIE
Hmmmm?

 DYLAN
I'm ready. Let's do it.

 ARIE
What?

 DYLAN
I thought about it some more and I think
you were right. I was just afraid.
I see that now.

 ARIE
Really?

 DYLAN
Yes. You... don't seem happy.

 ARIE
I'm happy. I'm happy! Just surprised.

They both stare at each other smiling a little too long.

 DYLAN
Soooo...

 ARIE
Yeah. So when were you thinking?

 DYLAN
Now.

 ARIE
Now!?

 DYLAN
Yeah. You seemed ready are you not
ready? I'm sorry. You're not ready.

 ARIE
No. No. I'm... ready.

Arie takes a deep breath and they smile at each other.

Blair and Jan huddle against a wall next to each other. They
whisper.

 BLAIR
 I'm scared

 JAN
 Shhhh...

 BLAIR
 Aren't you scared?

 JAN
 Best to be quiet right now.

 BLAIR
 The quiet makes it worse. I'm scared.
 Talk to me.

 JAN
 Okay. What do we talk about?

 BLAIR
 Are you scared?

 JAN
 No. We're going to be fine.

 BLAIR
 No? Really? How can you not be afraid?

 JAN
 Because we're going to be okay now.

 BLAIR
 So were you scared before?

 JAN
 I don't know. I guess. Does it matter
 now?

 BLAIR
 Yeah, because I panicked. I'm a coward!

 JAN
 You're being hard on yourself.

Blair is not comforted. Jan considers.

 JAN
 Look, I was afraid... I am... still
 afraid.

Beale approaches Rowan sheepishly.

> BEALE
> I'm sorry.

> ROWAN
> Are you?

> BEALE
> Yes. That's what I said.

> ROWAN
> You don't sound sorry.

> BEALE
> You're not making this easy.

> ROWAN
> Am I supposed to make this easy? Are
> you sorry or is this about me now?

> BEALE
> You're right. Sorry again, I guess.

> ROWAN
> Please, you're not sorry. You're not
> sorry at all.

> BEALE
> I came in. I said I was sorry. I don't
> know what else to do.

> ROWAN
> Mean it?

Beale sighs.

> BEALE
> I'm sorry. I really am. I lost my
> temper. I was stupid. Okay?

> ROWAN
> I so don't believe you.

> BEALE
> I was sorry, but now I'm not sorry at
> all. I couldn't be less sorry.

Beale storms away.

> ROWAN
> Yeah, I knew it.

 STACY
I'm just going to spit this out. I
don't know how else to do it. I'm gay.

 J.R.
You are not. Don't be stupid.

 STACY
I know this is weird for you. It's
weird for me, but I need you to know.

 J.R.
Are you serious? You're not serious.
I've known you for too long.

 STACY
I know, I dated Robin and Yoshi, right?
I didn't always know. I was confused
for a long time, but not anymore.

 J.R.
There's only one way to be sure, right?

 STACY
Where are you going with this?

 J.R.
Who?

 STACY
I tell you and you'll believe me?

J.R. nods "yes".

 STACY
Leeds.

 J.R.
Leeds is gay!? No way.

 STACY
You can't say anything to Leeds, but
yes. So... are you okay with this?

 J.R.
Of course. It's a lot to absorb, but
why should it bother me? You and Leeds,
though, wow. Nice catch, I guess.

 STACY
Thanks.

Emory sits across from Hatcher.

> EMORY
> I'm lost. Things with Shane are so
> dysfunctional, but in my gut, I don't
> really want to break up.

> HATCHER
> But what's the bottom line for you?

> EMORY
> Are you not listening? I just don't
> know. Surely you've got an opinion.

> HATCHER
> I'm just here to listen.

> EMORY
> You know you're not a licensed therapist
> or something. At least tell me if you
> have an opinion.

> HATCHER
> Why does that matter?

> EMORY
> That tells me whether it's me making
> this hard.

> HATCHER
> Don't judge yourself.

> EMORY
> Jeez, really? I just need a little
> advice, what's wrong with you?

> HATCHER
> Okay, I do have an opinion, but you
> won't like it.

> EMORY
> Are you kidding? I've been begging for
> it. Tell me.

> HATCHER
> I hate Shane. I've always hated Shane.
> You're better off separated.

> EMORY
> Yeah, you were right, I don't like it.

ANDY
You think you're so smart don't you?

D.
I don't know what you're talking about.

ANDY
Never admit anything, will you? But I'm
on to you, been on to you for a while.

D.
On to me? What have I done?

ANDY
I know what you did to Chen and George
and I know you got into Vivien's ear
about me too.

D.
What do I have to do with Chen and
George? And for you to blame your
problems with Vivien on me, well...

ANDY
I know you won't admit to anything, but
let's see how smart you feel after you
talk to Merce.

D.
Did you say something to Merce?

ANDY
Never admit to anything, right?

D.
You know what I said to Vivien? I said
you were a catch—a catch. I admit *that*.

ANDY
You're not serious. Are you serious?

D.
Now what did you say to Merce?

ANDY
Yeah, I need to make a call.

Andy leaves quickly.

D.
You better be calling Merce.

Rene and Ollie sit next to each other reading.

> RENE
> My sister got a new car.

> OLLIE
> Hmmm?

> RENE
> My sister, she got a car, brand new.

> OLLIE
> Great. I'm reading right now.

> RENE
> Oh? What are you reading?

> OLLIE
> Just this... thing.

> RENE
> Is it good?

> OLLIE
> Uh... I'm *trying* to read it.

> RENE
> Oh, oh, I got it. Something important
> for work or something?

> OLLIE
> No. Not really, but I still want to
> read it right now.

> RENE
> Oh.

Ollie returns to reading, but Rene's clearly hurt.

> OLLIE
> It's nothing personal.

> RENE
> Yeah. Of course.

> OLLIE
> I don't mind talking. I like talking
> with you, just not right now, okay?

Rene smiles. Ollie goes back to reading and Rene's smile
fades.

Emerson watches Leeds for a long moment.

> EMERSON
> Are you ready?

> LEEDS
> I think so.

> EMERSON
> We're not doing this till you're sure
> you're ready.

> LEEDS
> We may never do this then.

> EMERSON
> Really?

> LEEDS
> I mean, I'm going to be nervous. I'm
> going to have doubts.

> EMERSON
> Of course. You can be nervous, but
> still be ready. I am.

> LEEDS
> You're nervous?

> EMERSON
> I am.

> LEEDS
> That's good to know. You don't seem
> nervous.

> EMERSON
> I am. You don't seem that nervous
> either.

> LEEDS
> Now you're lying.

> EMERSON
> Maybe.

They share an intimate smile.

> LEEDS
> I'm trusting you.

Jules ushers Q. inside.

> JULES
> C'mon in. You're the neighbor across
> the way, right? I've seen you.

> Q.
> Yeah. I've seen you too.

> JULES
> Glad to meet you in person. Always nice
> to know your neighbors.

> Q.
> Yeah, of course.

> JULES
> I'm particularly glad you came over
> though. Ever since I saw you, I kinda
> wanted to talk to you.

> Q.
> Oh? Is there something...?

> JULES
> Not exactly. I was just... intrigued.

> Q.
> Are you... flirting with me?

> JULES
> Maybe.

> Q.
> Yeah... You should know, I came over to
> ask you to close your curtains when
> you're walking around, you know...
> naked.

> JULES
> Oh.

> Q.
> Yeah.

Q. starts to leave.

> JULES
> Hey, I'm still intrigued.

> Q.
> Keep it to yourself, okay?

 OBIE
What's going on? You look so serious.

 ARCHER
Huh? Oh... It's just that I've been
thinking a lot about something.

 OBIE
Yeah? What?

 ARCHER
I'm thinking about... experimenting.

 OBIE
Like a... scientist?

 ARCHER
...Sexually.

 OBIE
Ohhh...

 ARCHER
I feel like... maybe I've taken my
sexuality for granted when I need to...
kind of explore it.

 OBIE
Good for you, then. I totally support
you. If you're curious, you should-

 ARCHER
...With you.

Obie tries to take it in.

 ARCHER
I'm sorry. I know I'm putting you in an
awkward position. I just felt this
thing and thought if I didn't at least
try— but I didn't mean to put you—

 OBIE
Yeah.

 ARCHER
Yeah?

 OBIE
Yeah!

 GOLDWYN
 Are you into Parker?

 KINGSLEY
 Why, are you?

 GOLDWYN
 I am a little. What about you?

 KINGSLEY
 I am sort of.

 GOLDWYN
 I see.

 KINGSLEY
 Yeah. So how do we work this out?

 GOLDWYN
 Do we have to work it out? This will
 work itself out, won't it?

 KINGSLEY
 You mean if we both make a move, Parker
 will have to decide, right? But one of
 us will have wasted a lot of effort.

 GOLDWYN
 It won't be me.

 KINGSLEY
 Well, it definitely won't be me.

 GOLDWYN
 I thought you were only "sort of" into
 Parker

 KINGSLEY
 I got more interested.

 GOLDWYN
 I got really interested.

 KINGSLEY
 Too bad for you then.

 GOLDWYN
 No, too bad for you.

Kingsley and Goldwyn turn away from each other.

Kaya and Merle are looking over some papers together.

 KAYA
So, are you in a relationship?

 MERLE
Long story.

 KAYA
Ooh... What happened?

 MERLE
Yeah... I think we should get back to
work here.

 KAYA
We're being paid either way.

 MERLE
Yeah, but we're being paid to work.

 KAYA
Am I being too flirty here?

 MERLE
Let's just get back to this.

 KAYA
Ouch, sorry, I thought maybe you were
interested. How embarrassing, sorry.

 MERLE
No... That's not it. This job is just
really important to me. We can flirt.
I'd like to flirt with you, just not
here.

 KAYA
Oh? Where?

 MERLE
Anywhere where we're not supposed to be
working. Maybe if we went out for a
bite or something.

 KAYA
A bite. Really?

 MERLE
Yeah. And, no, I'm not in a relationship,
okay? But the rest later.

 PARKER
 Is everything okay?

 SAM
 Peachy.

 PARKER
 I'm serious.

 SAM
 Aren't you always?

 PARKER
 This is exactly what we talked about.

 SAM
 What?

 PARKER
 You turning everything around back at me
 somehow.

 SAM
 Okay, you're right. My bad. I'm sorry,
 okay? Happy now?

Parker sighs, unamused.

 PARKER
 You're still trying to make this about
 me.

 SAM
 Okay, what am I supposed to do then?

 PARKER
 Answer the question.

Sam stares blankly.

 PARKER
 Is something wrong? Is everything okay?

 SAM
 Oh, yes, of course.

 PARKER
 Really? This is important, right?

 SAM
 Yes.

Desi and Cutler are staring at a piece of art on a wall.

> DESI
> Did you do this?

> CUTLER
> Do you like it?

> DESI
> I do. Is it yours?

> CUTLER
> It is.

> DESI
> It's great, but would you have denied
> making it if I didn't like it?

> CUTLER
> Wouldn't you?

> DESI
> No. Never. Someone's going to dislike
> your stuff no matter how good it is.

> CUTLER
> I guess, but I'd just as soon not be
> confronted by those people.

> DESI
> What!? Embrace it! If everybody likes
> your stuff, you're not taking any
> chances. You're playing it safe.

> CUTLER
> So I should be glad when somebody
> doesn't like it?

> DESI
> Exactly. A true artist expects it,
> wants it.

> CUTLER
> Wow. I never thought of it that way,
> but you're totally right.

> DESI
> Good. Because, I don't really like it.

Desi walks away.

J.D. runs in, startling Marion.

> J.D.
> I can't let you go.

> MARION
> What? You're kidding. This is a joke, right?

> J.D.
> No. I'm serious. I really am.

> MARION
> Really? Now?

> J.D.
> I guess I needed to think I was losing you to realize what you meant to me.

> MARION
> Where were you when I first brought up this move? Where have you been all these months I've been planning?

> J.D.
> Isn't it more... romantic now?

> MARION
> No. It just makes me think you're panicking and not thinking straight.

> J.D.
> Jeez you're so logical. I really pictured this going differently.

> MARION
> Life's not a movie.

J.D. sits, discouraged.

> MARION
> Sorry, I gotta get going.

> J.D.
> So what then?

> MARION
> I don't know, maybe if you feel the same way in a month, you can come and see me. We'll go from there.

J.J. approaches ROAN who clearly wants to be left alone.

> J.J.
> It gets better.

> ROAN
> Awesome. Thanks. Got any other good
> clichés?

> J.J.
> It's not your fault.

Roan scoffs.

> J.J.
> Really. It's not. You're taking this
> too hard.

> ROAN
> Why don't you let me worry about how I'm
> taking this?

J.J. regroups.

> J.J.
> I'm trying to help. You understand
> that, right?

> ROAN
> Try less.

> J.J.
> That's how it is?

> ROAN
> Yes! That's how it damn well is! Am I
> being unclear or something!?

J.J. backs off.

> J.J.
> You're hurting, I can see that.

> ROAN
> No duh. Now leave me the hell alone, so
> I can get to it.

J.J. starts to leave, but stops short.

> J.J.
> No.

Robin enters, troubled.

 ROBIN
Just now, you came into the bathroom.

 TEAGUE
Yeah?

 ROBIN
I didn't say anything, because I was
kind of shocked, but... Not cool.

 TEAGUE
Yeah. Sorry, it was an emergency.

 ROBIN
Still. Knock, tell me, I'll get out.

 TEAGUE
You know, things get urgent, you don't
think straight.

 ROBIN
Whatever. Just so we're clear now.

 TEAGUE
Clear, but I think you're kind of making
a deal out of this.

 ROBIN
It is a deal.

 TEAGUE
Not really. Ever been in a public
toilet? And I hope we're a little more
comfortable with each other than we are
with strangers.

 ROBIN
If you feel that way, great—big family,
whatever—I don't. Don't like public
toilets either.

 TEAGUE
Okay, but just because you're hung up,
don't make it seem like I'm out of line.

 ROBIN
You are. You're way out of line. I am
not the only person that values a little
privacy.

 JAXX
I don't want to talk to you.

 MISCHA
Then just listen.

 JAXX
To more lies?

 MISCHA
It wasn't me. Let me explain.

 JAXX
I saw you with my own eyes!

 MISCHA
See that's it. You didn't.

 JAXX
Are you crazy? This is your
explanation? You expect this to work?

 MISCHA
No, not really. But it's the truth.

 JAXX
I like the earnestness, nice touch, but
wrap this up.

 MISCHA
I'd have never done anything like that.
I would never hurt you. What you saw.
It wasn't me. It was...

 JAXX
This is gonna be great...

 MISCHA
You're not giving me a chance.

 JAXX
You don't deserve a chance. You don't
deserve my time. You never did. You're
worthless. At least I see that now.

Jaxx marches off defiantly. Mischa fumes.

 MISCHA
You know what? It was me! And I'm glad
you saw me!

 SAL
I've got to let you go.

 TAYLOR
Phfft- Wha- Are you serious?

 SAL
It's just not working out.

 TAYLOR
This isn't funny.

 SAL
No. It certainly isn't.

 TAYLOR
Not working out? Two years. That's
what I get?

 SAL
Sorry, but... it's not working out.

 TAYLOR
I never miss work. My productivity
numbers are off the charts.

 SAL
I'll write you a great rec.

 TAYLOR
What's not working out?

 SAL
Sometimes employees... just aren't the
right fit.

Taylor stares at Sal till Sal has to turn away.

 TAYLOR
What is this really about?

 SAL
I told you.

 TAYLOR
After two years, you owe me a hell of a
lot better than that.

 SAL
You damn well know what this is about!
Do you really have to make it so hard!?

 TERRY
 What... What happened?

Terry is dazed and jittery, close to shock.

 YEE
 You just had a big scare.

 TERRY
 There... there were gunshots...

 YEE
 Yeah. It's over now.

 TERRY
 What are you doing? What do you want?

 YEE
 Just trying to help.

Terry is starting to panic.

 TERRY
 How do I know you... I mean, I think—

 YEE
 Look at me. Look at me.

 TERRY
 What, what?

 YEE
 It's over now.

 TERRY
 Right, right...

 YEE
 Try to relax.

Terry calms down a little.

 TERRY
 Am I okay?

 YEE
 You will be. It's over now

 TERRY
 Yeah, it's over... it's over...

 B.B.
 Did you do this?

Raley looks away from a painting, nods "yes".

 B.B.
 It's great.

 RALEY
 Please...

 B.B.
 No it is. It's really great.

Raley shrugs.

 B.B.
 Trouble taking compliments, much?

 RALEY
 You're right. Thanks. It's just
 that... it was rushed.

 B.B.
 Doesn't mean it's not good. The lines
 have so much energy. I think it's the
 spontaneity that I like.

 RALEY
 I'm glad someone likes it.

 B.B.
 Can I have it?

 RALEY
 What? I don't even know you.

 B.B.
 Be flattered. Your mom probably has
 enough of your stuff already.

 RALEY
 My dad, actually.

They share a smile.

 B.B.
 Well?

 RALEY
 Sure, but you'll have to buy me a drink.

 MICHELE
 Is that your Psych textbook?

Yutaka looks up from reading.

 YUTAKA
 Yeah.

 MICHELE
 Didn't you take Psych last semester?

 YUTAKA
 Yeah, so?

 MICHELE
 Why would you read it now then?

 YUTAKA
 Uh... It's interesting...

 MICHELE
 Seems kinda dumb to me. I'm sure you
 have stuff you have to read for this
 semester. What's the point?

 YUTAKA
 Dumb? Really? I know how superior you
 feel with your perfect GPA and all, but
 I happen to think it's smarter to learn
 than to obsess over grades.

 MICHELE
 We'll see how smart it is when you try
 to go to grad school.

 YUTAKA
 If I have to sacrifice my learning in
 order to line things up for grad school,
 something's wrong in the system.

 MICHELE
 Welcome to the real world.

 YUTAKA
 Yeah, well, you can have it.

Yutaka goes back to reading.

 MICHELE
 Oh I do... On a string.

Akira walks in.

 AKIRA
 Wasn't that the door? Aren't you going
 to get that?

 CODY
 Shhhh! Come here.

Cody beckons Akira over to a hiding place against a wall.

 AKIRA
 What's going on? Are you hiding?

 CODY
 Yeah. Just be quiet.

 AKIRA
 Who from? An ex?

 CODY
 It's the landlord.

 AKIRA
 The landlord? Why do you need to hide
 from the landlord?

 CODY
 Shhh... We're behind a little on rent.

 AKIRA
 How is that possible? I paid you my
 half.

 CODY
 I know. I just missed a payment or two.

 AKIRA
 You at least have my part, right? Just
 open the door and pay her some.

 CODY
 I... Uh... Yeah, it's complicated.

 AKIRA
 I had a feeling about you as a roommate,
 but things seemed to be going so good.

 CODY
 Yeah, always trust your gut, now shhh!

 AVI
Jess and I are going someplace downtown
for dinner.

 HOLLIS
You know, I don't really need a play by
play of everything you and Jess do.

 AVI
Wow. Jealous much?

 HOLLIS
Please. It just gets old. Why would
anybody want to know every single little
detail about you guys?

 AVI
I don't know, maybe because we were
friends? Just make a list of what I can
and can't tell you about.

 HOLLIS
Okay, you're right, sorry, you don't
have to get crappy about it.

 AVI
I can cut back on the updates.

 HOLLIS
I'd appreciate it.

Avi is about to leave, but stops

 AVI
Tell me why, though.

 HOLLIS
What? Never mind, just tell me whatever
you want. Sorry I brought it up.

 AVI
C'mon, this is part of being friends
too. What's going on?

 HOLLIS
You're right, okay, it is hard when I
don't have anybody. I'm happy for you,
really, but it hurts a little too.

 AVI
Now I got it. Thanks.

Abi and Park sit next to each other waiting.

> ABI
> I shouldn't be nervous, right? It's
> just a test.

> PARK
> Just a test, yeah. You'll be fine.

> ABI
> Yeah.

> PARK
> Yeah.

Uncomfortable silence.

> ABI
> I should think about something else,
> shouldn't I?

> PARK
> Something else?

> ABI
> You know... other than...

> PARK
> Other than the test, right?

> ABI
> Yeah.

> PARK
> Of course. You're right. Anything else
> would be better. Positive thoughts.

> ABI
> Talk to me about something then.

> PARK
> Uh... I... Uh... Crap, I'm letting
> you down, I know. I'm just scared too.

> ABI
> No. Don't feel bad. All that matters
> is you're here. Really. It makes
> things so much better.

Park takes Abi's hand. It's hard to tell who's more grateful.

 JANKS
You look fantastic.

 PERRY
Yeah right. What do you want?

 JANKS
Really? I can't even give you a
compliment?

 PERRY
As long as you're not after something.

 JANKS
Wow. It's like I can't say anything.

 PERRY
Okay, sorry, maybe I'm wrong. Tell me
you're not going to bring up my parents.

Janks is stopped cold.

 JANKS
That's not fair.

 PERRY
I knew it. You were setting me up.

 JANKS
No. I wasn't even thinking that. I
gave you a legit compliment and you're
trying to turn it around so now I can't
even bring up your parents.

 PERRY
I knew this was about my parents.

 JANKS
You made this about your parents.

 PERRY
Don't you dare blame me. You're the one
who hates my parents.

 JANKS
Oh, my God, you are crazy!

Perry stalks off, livid.

 JANKS
Just like your parents!

Sully walks in, serious and determined.

> SULLY
> Were you telling people about J.D. and
> Ashton?

> TAO
> I might have mentioned it.

> SULLY
> Not cool.

> TAO
> Was it a secret? I didn't know.

> SULLY
> Not the point, really. Just stop with
> the gossip already.

> TAO
> What do you mean? I never told anyone
> anything about you.

> SULLY
> Not the point. Gossip, it's just ugly.
> Stop it.

> TAO
> Wow, really? You're going to tell me
> how to live my life?

> SULLY
> Live your life how you like. I'm just
> telling you what to do if you want to
> stay friends with me.

> TAO
> Feel pretty strongly about this?

> SULLY
> I do. Okay? I've been hurt by gossip
> before. Really hurt. Gossip's hurtful.
> There's no good in it.

> TAO
> Oh... I don't think I... understood.

> SULLY
> Yeah, it was clear you didn't. Now you
> do.

 GREER
What's wrong with you lately?

 CHEN
I've just been lonely.

 GREER
Really? You have a lot of friends.

 CHEN
I know. It's just how I feel. We do
lots of stuff... but I just feel like...
sometimes I'm with you guys and I'm
still lonely. I'm still not connected.

 GREER
You mean like you need a romantic
relationship?

 CHEN
Maybe I'd be connected more in a
romantic relationship. I don't know.
I'm sorry to bother you.

 GREER
It's okay, I want to help. Is there
something I can do?

 CHEN
No. You've got Arie already. That's
the kind of friend I need.

 GREER
Arie?

 CHEN
You know, that sort of close friend
where you share everything.

 GREER
Me and Arie? Arie never tells me
anything. Doesn't exactly invite me to
confide either. Arie's great and we get
each other's jokes, but I wish I had the
kind of friend you mean.

 CHEN
Really? You know... That kind of makes
me feel better.

Chen smiles. Greer tries to share it, but is troubled now.

Annup walks in and sits down next to Paxton, smiling.

 PAXTON
Leave me alone.

 ANNUP
You're mad at me?

 PAXTON
I just can't do this... now.

 ANNUP
Do what?

 PAXTON
Not... *now*.

 ANNUP
Okay.

Annup stops talking, but continues to sit next to Paxton, smiling. Paxton tries to ignore Annup.

 PAXTON
What part of "leave me alone" do you not understand?

 ANNUP
I didn't say anything.

 PAXTON
Please, really, just leave. I can't...
You know... Right? You know... I know
you know.

 ANNUP
No. I really don't know. I don't
understand. I don't. Tell me.

A long pause. Paxton considers.

 PAXTON
NOT. NOW.

Annup gets up, stares at Paxton for a long time. Paxton stares back, unblinking. Annup finally turns and walks away sadly.

 ANNUP
Thanks. Now I do understand.

> JEAN
> You ready for a drink!

> MU
> Naw. We've been drinking too much
> lately.

> JEAN
> No. Really? We drink too much?

> MU
> It's not good to drink every night.

> JEAN
> I suppose you're right. Wouldn't hurt
> to ease up. Just not tonight, though.
> It's been a rough day.

> MU
> You can go ahead and drink if you want.
> I'm not stopping you. I'm good though.

> JEAN
> Don't make me drink alone. I already
> feel bad enough.

> MU
> That bad a day?

> JEAN
> You don't even wanna know. C'mon, one
> drink won't kill you.

> MU
> One?

> JEAN
> Yeah, just have one with me.

> MU
> And you'll just have one?

> JEAN
> C'mon now, you said you didn't care if I
> drank. You can nurse yours.

Mu sighs.

> MU
> And so it begins.

Hadley enters, home from work.

> HADLEY
> You sure are in a good mood.

> AMAL
> Yeah. Good day, I guess.

> HADLEY
> What happened?

> AMAL
> Nothing really, just finally did
> something.

> HADLEY
> Yeah. That's great. You get the yard
> cleaned up, what!?

> AMAL
> No... nothing important, really.

> HADLEY
> Don't bring this up and not tell me.

> AMAL
> I... uh... got to level five...

> HADLEY
> Level five? Like in a video game?

Amal nods "yes".

> HADLEY
> Finally, huh? Been at it a while?

> AMAL
> I played for an hour... at lunch.

> HADLEY
> So then I'm guessing you didn't get
> anything done around here.

> AMAL
> You're right. I shouldn't— I won't
> play again... during the day.

Hadley walks out, hardly satisfied. Amal mumbles.

> AMAL
> ...Once I get to level six.

 TILLER
So, Terry says to me today that I
haven't been working hard enough. Can
you believe that?

 WEN
Terry said that? Why do you think?

 TILLER
I don't know—bad mood—who knows. Why
pick on me though?

 WEN
Yeah. You been workin' hard, right?

 TILLER
You know me, I always work hard.

 WEN
Of course, but why'd Terry say that?
Could have said anything, right?

 TILLER
What do you mean? Are you hinting that
Terry might be right?

 WEN
No. I'm sure Terry was off base, but
sometimes there's a kernel of truth or
something in a criticism like that.

 TILLER
Are you seriously taking Terry's side?

 WEN
I'm not taking Terry's side, but how do
I know what happened? I wasn't there.

 TILLER
I told you! That should be the end of
the story. I'm not asking for a damn
scientific analysis here. I'm just
looking for a little basic support.

 WEN
Oh.

Tiller storms out, livid. Wen yells after.

 WEN
Terry's a jerk! Hating Terry right now.

 CASSIDY
You were drunk last night.

 HYDEN
Not really.

 CASSIDY
Not really? You were puking half the
night.

 HYDEN
Something didn't agree with me.

 CASSIDY
Yeah, like six drinks.

 HYDEN
I did not have six drinks.

 CASSIDY
How many, then?

 HYDEN
I don't know. Who counts?

 CASSIDY
People who have to drive home?

Hyden smiles sheepishly. Cassidy waits for acknowledgement.

 HYDEN
Okay, whatever... You got me. I had a
few. I shouldn't have been driving.
What do you want from me?

 CASSIDY
I want to know it won't happen again.

 HYDEN
I think your heart's in the right place
here, but you need to back off.

 CASSIDY
So that's it? I'm being overbearing
here? Hmm. Tell me, really, am I just
stupid to care?

 HYDEN
Stupid's a strong word, but... yeah,
kinda.

 FOSTER
What do you think about renting that big
place on the first floor?

 LI
I couldn't afford that.

 FOSTER
Yeah, but *we* could.

 LI
We? A little early for that isn't it?

 FOSTER
Why is it too early?

 LI
We haven't been going out that long.

 FOSTER
Really? How long is long enough?

 LI
I don't know, but longer than this.

 FOSTER
How much longer?

 LI
I don't know. You can't put an exact
schedule on something like this.

 FOSTER
My point exactly. As long as you feel
the way I do, why not now?

 LI
Well... I guess... I'm not sure I
feel... exactly the way you do.

 FOSTER
Oh... I see.

 LI
I'm sorry, I don't mean to hurt you. I
might want that eventually, even soon.

Foster musters a smile.

 FOSTER
I don't like ground floors anyway.

 SIMM
I am so screwed!

Mac sighs deeply

 SIMM
What?

 MAC
Nothing. Go on.

 SIMM
I totally forgot, it's my parents
thirty-third.

 MAC
What are you talking about? I saw the
card you got them. It was nice.

 SIMM
Yeah, but it's their *thirty-third*.

 MAC
Is that a thing?

 SIMM
I want to do something nice for them.

 MAC
Okay, but that doesn't mean you're
screwed does it? I mean, there's no
expectations on this really?

 SIMM
So, I'm over-reacting. Is that it?

 MAC
You said it, not me.

 SIMM
Jesus, I can't react to anything.

 MAC
Just a little less drama.

 SIMM
How's this for less drama.

Simm storms out.

 MAC
Technically, I think that's more drama.

Ayah tries to stop Robbie who's trying to get out.

> AYAH
> What are you doing tonight?

> ROBBIE
> I'm going with Cam and Brooklyn to see a
> band that Cam knows.

> AYAH
> Sounds like fun.

> ROBBIE
> Yeah. Cam got the tickets already.
> Otherwise I'd say come along.

> AYAH
> Of course, another time then...

> ROBBIE
> Of course.

> AYAH
> Maybe tomorrow...

> ROBBIE
> Yeah. Oh... but not tomorrow. I'm
> going out with Cody tomorrow.

> AYAH
> Sure. But... soon.

> ROBBIE
> Yeah. You should do something though.

> AYAH
> Yeah.

> ROBBIE
> Maybe go out with Paz?

> AYAH
> Paz is already— Never mind. I'm fine.

> ROBBIE
> Okay. I was just thinking maybe you
> were a little... lonely.

> AYAH
> No. I'm fine.

 CASEY
 This place is dead. Let's head down to
 Terry's.

 ZED
 Just like that?

 CASEY
 Yeah, just like that. Is there a
 problem.

 ZED
 Maybe I have an opinion.

 CASEY
 You have an opinion?

 ZED
 Yeah, maybe I'm having a good time here.
 Maybe I have somewhere else I want to
 go. Why am I never included in these
 decisions?

 CASEY
 I don't have you on a leash. You don't
 have to go to Terry's if you don't want
 to.

 ZED
 That's no excuse. If you had any
 respect for me, you'd include me in the
 decision and not just inform me once
 it's made.

Casey considers for a long moment.

 CASEY
 I never thought of it that way. That
 really hurt your feelings?

Zed nods "yes".

 CASEY
 Well, then. What do you think we should
 do?

Zed must think on this a moment.

 ZED
 I guess, let's head over to Terry's.

>TARYN
My parents are gonna be in town this
weekend. Wanna get dinner together?

Gail jumps up, begins pacing around thinking.

>TARYN
What? What's wrong?

>GAIL
That's a big step. Meeting the parents,
that's a we're—serious step.

>TARYN
We're not serious?

>GAIL
Well, not that serious... *yet*.

>TARYN
Look, they just happen to be in town.
It's no big deal. We'll know that we're
"not that serious yet".

>GAIL
But will they know?

>TARYN
What does it matter if they know?

>GAIL
If they think we're serious, they'll
influence you, start pushing you or
something to make it more serious.

>TARYN
Is that a bad thing?

>GAIL
It is if you push it too fast. It could
ruin everything.

>TARYN
Are we so fragile? Just forget it,
then. I don't think I really want you
meeting my parents anyway.

>GAIL
Are you sure? That's a big decision
too.

Christian looks at a phone.

 CHRISTIAN
You posted about my surgery!

 RAYA
What? Yeah, so?

 CHRISTIAN
I didn't say you could. That was
personal.

 RAYA
Who has secrets like that anymore? It's
no biggie.

 CHRISTIAN
It was totally personal. I don't want
people knowing that.

 RAYA
People post truly embarrassing stuff
about themselves everyday.

 CHRISTIAN
That's them. This is not your call.

 RAYA
Okay, but the point I'm trying to make
is how was I supposed to know?

 CHRISTIAN
Just ask first.

 RAYA
You sound like my mom. That's not how
things works anymore and you know it.
I'll do whatever, but give me a clue.

 CHRISTIAN
Really? This is on me?

 RAYA
Don't be so dramatic. Nobody cares.

 CHRISTIAN
I care. I value my privacy.

 RAYA
Whatever that used to be.

 SHAWN
 Did you borrow my nice jacket?

 BRYLE
 Yeah, sorry. I couldn't find you.

 SHAWN
 We had a deal about asking, remember?

 BRYLE
 You didn't need it did you?

 SHAWN
 That's not the point. We had a deal.

 BRYLE
 Yes, I said I was sorry. Now, did you
 need it?

After a moment, Shawn nods "no".

 BRYLE
 I didn't think so.

 SHAWN
 What is that supposed to mean?

 BRYLE
 If I thought you needed it, I wouldn't
 have borrowed it.

 SHAWN
 That's not what you meant.

 BRYLE
 Okay, I meant there wasn't much chance
 that you'd be going out.

 SHAWN
 That is majorly messed up.

 BRYLE
 ...But true. At least someone gets some
 use out of the jacket.

 SHAWN
 New deal: you never even touch anything
 of mine again.

Shawn storms out.

Cam charges in.

 CAM
 You don't have the game on. Let's put
 the game on.

 WELLER
 I'm good.

 CAM
 You don't wanna watch the game?

 WELLER
 No.

 CAM
 But it's the playoffs?

 WELLER
 Don't care.

 CAM
 What's going on? You never miss a game.

 WELLER
 No. *You* never miss a game. I can take it
 or leave it

 CAM
 You mean... No, you're a fan. You
 can't tell me you're not a fan.

 WELLER
 Not like you. I can take it or leave
 it. And I'm leaving it.

 CAM
 Is this about Sage?

 WELLER
 I'm tired of all your stupid crap. All
 the dumb game superstition, the lame
 catch phrases. I'm done with all of it.

 CAM
 I know this is about Sage. I'm sorry
 about that, but let's not let it screw
 things up between you and me.

 WELLER
 I'm just not a fan anymore.

Bradley walks in and looks around.

 BRADLEY
 I thought you were going to clean up?

 KRAMER
 I did the best I could.

 BRADLEY
 Really? This is your best?

 KRAMER
 It was today, okay? Sorry, I'm just not
 perfect.

 BRADLEY
 Perfect? I'm talking about picking up,
 and maybe running a vacuum.

 KRAMER
 What's the point, I can't live up to
 your standards no matter what I do.

 BRADLEY
 Okay, is something going on?

 KRAMER
 No, I just didn't do a good job, okay?
 I'm sorry. Get off my back.

 BRADLEY
 Forget about that. Everything else is
 okay? You're okay?

 KRAMER
 I'm okay.

 BRADLEY
 Everything's okay?

 KRAMER
 You're not mad about the house, really?

 BRADLEY
 No. Just tell me what's going on.

 KRAMER
 I wrecked the car.

 BRADLEY
 Yeah... perfect you are not.

Jordie and Zhao wake up on the ground.

> JORDIE
> Oh, my head. Last thing I remember were
> those shots. What happened after that?

Zhao shrugs, trying to wake up.

> JORDIE
> You mean you don't remember either?

> ZHAO
> No, I mean nothing happened after that.

> JORDIE
> After the shots?

> ZHAO
> Yeah.

> JORDIE
> Well *something* happened, right?

> ZHAO
> What?

> JORDIE
> We passed out, right?

> ZHAO
> Right, yeah. That's all.

> JORDIE
> You're acting weird. Did something else
> happen? I kind of remember...
> dancing...

> ZHAO
> Yeah, I don't—

> JORDIE
> Dancing! Yeah! Old disco or something
> and then slow dancing... Slow
> dancing... with *you*... and then...

> ZHAO
> Nothing.

Jordie and Zhao share a look.

> JORDIE
> Yeah. Nothing.

Fran enters checking on Bille.

> BILLE
> This is just so painful. All I can
> think about is the pain.

> FRAN
> You know what you need? A good laugh!

Fran makes a silly face.

> BILLE
> Nothing's funny right now.

> FRAN
> Wait? How about this?

Fran does a goofy impression of a chicken.

> BILLE
> I appreciate the effort, really, but—

Fran switches to a monkey impression.

> BILLE
> Just getting weird now.

Fran does Frankenstein.

> BILLE
> Pretty good Frankenstein, but not funny.

Fran takes a moment to think. Get's an idea.

> BILLE
> Okay, this outta be good.

> FRAN
> Ow, ow! I'm in so much pain, nothing's
> funny, especially you, Fran. Ow, ow!

> BILLE
> That's kinda mean.

But Bille is chuckling. Fran imitates the chuckle.

> FRAN
> Now I'm gonna try to pretend like I'm
> not laughing.

Bille laughs more till they are both laughing together.

NOAM
What's up with the drinking?

PARIS
Doing really good. Haven't had a drink
in a month.

NOAM
Wow. Well, you're due then.

PARIS
You mean, to drink again?

NOAM
Yeah, like as a reward.

PARIS
I... uh... don't think that's how it
works.

NOAM
What, are you supposed to not drink for
the rest of you life? The object was to
get it under control, right?

PARIS
Yeah.

NOAM
A whole month. Mission accomplished,
right? I've never done that.

PARIS
I don't know.

NOAM
C'mon, I miss you.

PARIS
I'm right here.

NOAM
...The old you, the fun you. You know
what I mean.

PARIS
Yeah. I miss you too, but not as much
after this. I'm gonna pass.

Paris leaves quickly, leaving Noam to consider.

Brailey storms in.

>BRAILEY
>
>Did you buy new dishes?

>DOVER
>
>Yeah. Do you like them?

>BRAILEY
>
>What was wrong with the old ones?

>DOVER
>
>These are just nicer.

>BRAILEY
>
>Nicer? We don't have money for stuff
>like that.

>DOVER
>
>Don't worry, it was my money.

>BRAILEY
>
>Your money? What is your money? Isn't
>it all our money now? Shouldn't we
>decide together how we spend our money?

>DOVER
>
>You don't like them?

>BRAILEY
>
>What? That's not the point.

>DOVER
>
>You like them then?

>BRAILEY
>
>Wha... I... Yes. Yes, I like them, but—

>DOVER
>
>Great! I was worried.

Dover gives Brailey a hug. Brailey loosens.

>BRAILEY
>
>Okay, but *we* do need to watch *our*
>spending.

>DOVER
>
>Of course, of course. Can we talk about
>silverware, though?

K.C. and Jordan enter.

 K.C.
You see that!

 JORDAN
Is that money?

 K.C.
Looks like a couple hundred bucks.

K.C. looks around, scheming.

 JORDAN
Who would just leave that lying around?

 K.C.
Somebody who didn't really want it.

 JORDAN
You think? Who doesn't want—

 K.C.
It's ours for the taking.

 JORDAN
Somebody's coming back for that.

 K.C.
No chance. Who just leaves their money lying
on a table?

 JORDAN
Then why is it there?

 K.C.
Who cares, but if we don't take it,
somebody else will.

 JORDAN
Maybe it's a trap.

 K.C.
A trap? What are we flies? Rats?

 JORDAN
Not both of us.

Jordan walks out.

 ANGEL
What does D.J. have against me?

 FLANDERS
D.J.? D.J.'s good with you.

 ANGEL
I don't think so. You ever see the
looks I get.

 FLANDERS
Are you sure? D.J. just kind of looks
that way all the time.

 ANGEL
No. D.J.'s got it in for me.

 FLANDERS
Maybe what D.J. holds against you is
that you're paranoid.

 ANGEL
Paranoid?

 FLANDERS
Yeah. You always think people are out
to get you.

 ANGEL
So D.J.'s out to get me, because I think
he's out to get me?

 FLANDERS
It's off-putting. I'm telling you.
It's hard to have a good time with you,
when you're always obsessing and
worrying.

 ANGEL
Really? I had no idea. So I annoy you?
You don't have a good time with me.

 FLANDERS
Sometimes... yeah.

Angel considers a long moment.

 ANGEL
So you're against me too.

Flanders sighs.

 BRETT
I finally figured you out.

 RYE
What?

 BRETT
You just hate people like me.

 RYE
I'm lost here.

 BRETT
Oh, you act all tolerant and inclusive and
stuff but inside... yeah, it's a
different story.

 RYE
Watch where you're going here, this is a
pretty strong accusation and, frankly,
I'm pretty insulted.

 BRETT
Okay. Just answer this: do you treat me
differently?

 RYE
Differently than what?

 BRETT
Differently than anyone, Sal, Bobby,
Fitz... anybody.

 RYE
Those are different people that I have
different relationships with, so what?

 BRETT
Different. Exactly.

 RYE
Okay, you wanna know how different?
They're chill. They're not paranoid.
They're not angry. They don't have
victim complexes. They're likeable. I
like *them*.

Brett stares, stunned, struggles to respond, but is overcome
by emotion and runs out. Rye sighs deeply.

 REILLY
So how's that whole art thing working
out for you?

 ZOHAR
Don't act like you care. You're just
wanting to say I told you so.

 REILLY
What do you mean? I've always thought
your art was really special.

 ZOHAR
Special, huh? Well, I just sold a
painting.

 REILLY
Really?

 ZOHAR
Surprised?

 REILLY
What you get for it?

 ZOHAR
Hoping it wasn't much, aren't you?

 REILLY
Was it?

 ZOHAR
Ten thousand.

Reilly is surprised and needs a moment to recover.

 REILLY
Wow! Congrats. What a great start for
you.

 ZOHAR
Start? That's about the tenth or
twelfth painting I've sold. This year.

 REILLY
Really? Well, I better just shut up.

 ZOHAR
That would be really special.

 MONTANA
Me and Perry broke up.

 SANDEEP
Really? I'm so sorry. I knew Perry
would do this, though.

 MONTANA
I don't wanna blame Perry.

 SANDEEP
No. Screw Perry. I always hated Perry.

 MONTANA
Don't say that. I still care for Perry.

 SANDEEP
That's only because you're such a good
person, unlike you-know-who.

 MONTANA
It's not like that.

 SANDEEP
O.K. Tell me what happened.

Huge, uncomfortable pause for Montana.

 MONTANA
There was... someone else.

 SANDEEP
I knew it! I told you. Screw Perry!

 MONTANA
It wasn't Perry with someone else.

 SANDEEP
You?

 MONTANA
Nothing actually happened. I just...
fell for someone else.

 SANDEEP
Who?

 MONTANA
You.

> CORKY
> Do you really need to sit there?

Ronan looks up surprised, considers Corky for a moment.

> RONAN
> This is getting ridiculous. I think we should just sleep with each other and be done with it.

> CORKY
> What!? Why on earth would you say that?

> RONAN
> C'mon, it's obvious there's some kind of tension here.

> CORKY
> Yes, because I really dislike you.

> RONAN
> Are you saying sex doesn't interest you?

> CORKY
> That's a ridiculous question. I told you, I don't even like you.

> RONAN
> What's that got to do with it? Am I not attractive sexually?

> CORKY
> What kind of question is that?

> RONAN
> A very simple one really. I find *you* sexually attractive, *okay*?

> CORKY
> Well then, yes, I suppose I do too, but—

> RONAN
> ...Yeah, yeah, but you don't like me. I got it. It was just a thought.

> CORKY
> Strange sort of a thought...

Ronan turns away. Corky tries to forget about it, but can't help but steal looks at Ronan.

Sydney stumbles onto Franke who seems to be hiding.

 FRANKE
 Shhhh!

 SYDNEY
 What? What? What?

 FRANKE
 Quiet!

Sydney finally whispers like Franke.

 SYDNEY
 What are you doing?

 FRANKE
 Hiding.

 SYDNEY
 Really? How fun. Why are you hiding?

 FRANKE
 Promise you won't tell anyone, but I'm
 trying to avoid Taylor.

 SYDNEY
 Taylor? I hate Taylor. I wish I could
 avoid Taylor.

 FRANKE
 You can.

 SYDNEY
 How?

 FRANKE
 Hiding.

 SYDNEY
 Oh, right.

After a moment Sydney smiles.

 SYDNEY
 I thought I was the only one who hated
 Taylor. I'm glad we're hiding together.

Franke considers.

 FRANKE
 I am too.

Bertie walks in looking troubled.

 BERTIE
 I hit Selby...

 SAFAR
 What? Hit like punched?

 BERTIE
 Yeah, punched. Pow! You know...

 SAFAR
 What happened?

 BERTIE
 You know how Selby is... starts crap,
 never knows when to shut up. Things
 just escalated really fast.

 SAFAR
 Into a fist fight?

 BERTIE
 Well... it wasn't much of a fight.

 SAFAR
 What are you proud? Is Selby okay?

 BERTIE
 Of course. Just a fat lip. If I'd have
 really wanted to hurt—

 SAFAR
 You are proud. What is wrong with you?
 Selby's a friend.

 BERTIE
 Oh c'mon, Selby gets so arrogant, so
 self-righteous. Don't tell me you never
 thought about shutting that mouth.

 SAFAR
 Well...

 BERTIE
 Honest now...

 SAFAR
 As long as Selby's okay...

Safar shares a little smile with Bertie.

Ly studies a restaurant check.

 LY
Uh... It's six bucks.

 SANDY
I forgot my money. Can you spot me?

 LY
Wait. When did you realize this?

 SANDY
I don't know.

 LY
I'm just wondering if you knew before or
after you ordered that six-dollar latte.

 SANDY
What does it matter?

 LY
Because if you knew you didn't have
money, you should have asked if I minded
covering the bill before you ordered.

 SANDY
I didn't remember till just now, okay?

 LY
But you didn't even check. As soon as I
mentioned it, you knew you didn't have
money.

 SANDY
So what? Five bucks? Really?

 LY
"Really?". It's not the first time.

 SANDY
I'm sorry. I don't have the kind of
money you have. Do you really need to
put me through this? Does it make you
feel big or something?

Ly is chastened. Long awkward pause.

 LY
Sorry. Just... ask, okay?

Les enters, very agitated.

> LES
> Were you online today?

> MADISON
> Is that a serious question?

> LES
> Somebody posted something about me. You
> see it?

> MADISON
> Ah, so it's this again. Just calm down.
> I'm sure it's not that big a deal.

> LES
> It's not good.

> MADISON
> You're being a little crazy. You know
> you always overreact to this dumb
> stuff.

> LES
> It's kind of about you too.

> MADISON
> What!? What about me?

> LES
> Wait, I thought *I* was overreacting?

> MADISON
> Just tell me, okay? What!?

> LES
> You're right, it's probably no big deal.

> MADISON
> Okay, now it's obvious you're messing
> with me. There was clearly nothing
> about me.

Les smiles and walks out.

> MADISON
> Right?

Madison tries to shrug it off, but after a moment, pulls out a
phone and types furiously.

Lewton rushes in rattled.

 NEO
Are you alright? Did something happen?

 LEWTON
Seriously? You won't laugh?

 NEO
I asked, didn't I?

 LEWTON
There was... *something* in that room.

 NEO
Okay, what? A table? A lamp?

 LEWTON
You said you wouldn't joke.

 NEO
Technically I said I wouldn't laugh, but
go ahead, no jokes, no laughs. What was it?

 LEWTON
I'm not really sure. A presence.

 NEO
A presence... like a person?

 LEWTON
Kind of, but more of a... spirit.

 NEO
You mean like a ghost or something?
That's not possible.

Lewton nods gravely.

 NEO
C'mon, really? Probably a cold breeze
or something. Let's just go look.

Neo moves toward the door.

 LEWTON
Wait! It felt like something... evil.

That stops Neo, who looks hard at the room then back at Lewton
straining to maintain confidence.

 ABNEY
 My God, I'm starving.

 COREY
 Me too, let's get some tacos.

 ABNEY
 No, not tacos. I'm not into tacos right
 now.

 COREY
 Okay. Pizza?

 ABNEY
 Meh...

 COREY
 Chinese?

Abney shrugs.

 COREY
 Are you sure you're hungry?

 ABNEY
 Starving!

 COREY
 Okay, what do you want?

 ABNEY
 Vegan.

 COREY
 Vegan? What is wrong with you?

 ABNEY
 Hey, no need to get personal.

 COREY
 Mexican?

 ABNEY
 You already said tacos, you damn idiot.

 COREY
 Wow. Well, this idiot's going to get
 some tacos. You can get Vegan or you
 can starve, I really don't care.

 BROOKLYN
This is a really nice restaurant, okay?

 PAZ
You told me. I'll dress nice.

 BROOKLYN
Yeah, but you also need to kind of...
step up your manners.

 PAZ
Pinkie out, got it.

 BROOKLYN
Seriously. For me to enjoy this, I
don't want you to...

 PAZ
...Embarrass you? Who I really am
embarrasses you?

 BROOKLYN
I didn't say that.

 PAZ
I got you, though. I am what I am. If
I ain't good enough for your damn
restaurant, that can just be your thing.

 BROOKLYN
Please don't do this. I'm just talking
about a few things: napkin in your lap,
hold your fork right. It's important to
me. It shouldn't be that big a deal for
one night.

 PAZ
You ever think, maybe it's a big deal
for me to feel like I ain't the right
class for you. Like I gotta put a act
on to get with you?

 BROOKLYN
I... I never thought of it that way.
I'm sorry, forget the whole thing.

Brooklyn slumps, sadly. Paz watches and sighs.

 PAZ
Hey, I'll give it a try. If it's
awkward, though, it's the last time.

 CAMERON
 You won the tickets!

 LAKIN
 I won the tickets!

 CAMERON
 Awesome! I can't believe it.

 LAKIN
 Yeah, finally got lucky.

 CAMERON
 I'm so excited.

Lakin takes in Cameron for the first time.

 LAKIN
 Yeah. You are excited.

 CAMERON
 Sure.

 LAKIN
 I'm taking Jude.

 CAMERON
 Jude? Right... sure. Why not?

 LAKIN
 Still excited?

 CAMERON
 Okay, I thought maybe you would take me,
 but it's cool.

 LAKIN
 Is it?

 CAMERON
 No. Not really. Jude?

 LAKIN
 Jude. Yeah. I know that seems like
 salt in your wounds, but I'm not trying
 to hurt you. You know that?

 CAMERON
 Yeah... I guess. I was just... excited
 there for a minute.

 D.B.
This is really awkward to bring up.

 HUNTER
What?

 D.B.
Promise you won't take it wrong or get
mad or something.

 HUNTER
I don't know what it is, though.

 D.B.
Just promise.

 HUNTER
Okay. I'll do my best.

 D.B.
Stop... touching me so much.

 HUNTER
What? I don't... touch you.

 D.B.
Oh, you touch me. My arms, my back, my
neck, my knee, you do it all the time.
I don't like it.

 HUNTER
Really? Well if I do, it doesn't mean
anything. I think that's just me being
friendly.

 D.B.
Yeah. Too friendly.

 HUNTER
What are you saying? I'm some sort of
creep or something?

 D.B.
You promised you would take it well.

Hunter stews a moment, before storming out.

 HUNTER
Fine. Whatever. You should be grateful
anyone wants to touch you.

 PAT
 Just take the pill.

 BRYN
 I'm not sure I want to.

Bryn stares at the pill.

 PAT
 You're going to love it. It makes you
 feel great.

 BRYN
 Why do you want me to take it so badly?

 PAT
 I just want you to have a good time.

 BRYN
 I don't need this to have a good time.

 PAT
 It'll loosen you up. It'll be good for
 you.

 BRYN
 Am I not loose enough? Do you want to
 loosen me up.

 PAT
 Would it kill you to bust out a little?

 BRYN
 So you don't like me the way I am?

Pat sighs deeply.

 PAT
 You're making way too big a deal out of
 this.

 BRYN
 You're the one making this a big deal.

 PAT
 Okay, fine, whatever. Take the pill.
 Don't take the pill. I'm sorry I tried
 to melt your precious ice.

 BRYN
 Wow. Why don't you take that pill...
 and shove it!

Gahan enters. Harper springs up.

> HARPER
> I'm glad you're here.

> GAHAN
> Yeah. Why?

> HARPER
> I need you to talk me out of this.

> GAHAN
> What? I thought you wanted to go.

> HARPER
> I do, I guess, part of me does, but part
> of me doesn't.

> GAHAN
> That's tough. Can I help?

> HARPER
> Yeah, tell me, should I go?

> GAHAN
> Like what I would do if I were you?

> HARPER
> No. What *you* want. Do *you* want me to
> go?

> GAHAN
> No, of course, not.

> HARPER
> Why?

> GAHAN
> I'd miss you.

> HARPER
> Stop evading.

> GAHAN
> I... I... Would you really stay?

Harper takes Gahan's hand, smiles.

> GAHAN
> I do... You know... I love you.

Devyn approaches Carrol. The tension is palpable.

> CARROL
> Hi.

> DEVYN
> Hi.

> CARROL
> Thanks for coming.

> DEVYN
> I don't want it to be like that between
> us. I'm not like that.

> CARROL
> I'm glad.

> DEVYN
> But don't think this means—

> CARROL
> Oh, no, I just need to set things right.

> DEVYN
> Okay.

> CARROL
> Will you sit?

> DEVYN
> I don't know yet.

> CARROL
> Okay... Look, I wanted to apologize. I
> was wrong to... not be totally honest.

> DEVYN
> Right...

> CARROL
> I mean... I'm not trying to minimize.
> I lied... and... I know, I hurt you.
> You didn't deserve that.

> DEVYN
> It means a lot to hear you say that.

They share a smile and Devyn finally sits.

SHERM
Please don't sit Mel next to me.

ALI
Is there an issue?

SHERM
I... I just want to sit somewhere else.

ALI
So this is what?

SHERM
I don't know... I'd appreciate you
sitting me somewhere else. That's all.

ALI
So now you want something from me?

SHERM
Yeah, I guess. If you want to think of
it that way.

ALI
This is a favor. You understand? Not a
big deal, but if I do you a favor...

Sherm takes a long moment to reevaluate Ali.

SHERM
What's going on here? Did you sit Mel
there on purpose?

ALI
You want to move or not?

SHERM
I'm not sure now.

ALI
I can move you. I'm just saying...

SHERM
Yeah— No. I'll stay. I'll make it
work.

Ali is thrown as Sherm walks away.

ALI
I didn't sit Mel there on purpose. I'll
just move Mel, okay?

 WIN
 You like basketball, don't you?

 LESLIE
 What? Do I know you?

 WIN
 Not yet, but I have a feeling. Tell me,
 do you like basketball?

 LESLIE
 Uh, yeah, so what?

 WIN
 I knew it. And do you like movies?

Leslie nods "yes", still uncertain about Win.

 WIN
 There it is, I knew it... *fate*.

 LESLIE
 What? Everybody likes movies.

 WIN
 But basketball too? This is fate. I'll
 prove it. Favorite food?

 LESLIE
 You're just going to agree with whatever
 I say.

 WIN
 Okay I'll tell *you*... Mexican.

 LESLIE
 That's right... but creepy. I'm leaving.

 WIN
 You love the snow too, right? And dogs!

 LESLIE
 Just stop.

 WIN
 Please, I knew it the minute I saw you.
 Tell me you don't feel *something*.

 LESLIE
 I... Uh... Can't we just start slower?

Fitz and Sid sit awkwardly next to each other.

> SID
> You okay?

> FITZ
> Yeah. I guess. Just nervous.

> SID
> Right, of course— I mean, not "of
> course" like you should be nervous or
> something, more like... I'm nervous
> too.

Fitz smiles.

> FITZ
> So...

> SID
> Yeah, so...

They both laugh uneasily. Fitz suddenly stands up, startling
Sid.

> FITZ
> We've got to make this easier somehow.
> This should be easier, right?

> SID
> I don't know. Maybe not.

> FITZ
> Yeah. Maybe you're right.

Fitz sits back down.

> FITZ
> Just tell me it's going to be okay.

Sid takes Fitz's hand, makes eye contact

> SID
> It's going to be okay.

Fitz smiles.

> FITZ
> That makes it easier... kind of...

BRIAR

I had fun.

DUSTY

Yeah?

BRIAR

Tonight. With you.

DUSTY

Yeah. It was fun.

BRIAR

I mean... I'd like to do this again.

DUSTY

You mean... like a date? This wasn't a
date.

BRIAR

I know, I know... but I think a date...
I mean... I'd like to...

DUSTY

Go on a date?

BRIAR

Yeah, are you trying to make this hard?
If you're not into it, just say so.

DUSTY

I just didn't see this coming, I guess.
I need to process it.

BRIAR

Process what? It's a date. If it's too
weird for you, just forget it.

DUSTY

No, I had fun too, a lot of fun. It's
just, well... I haven't been on a date
since... I broke up with Archer.

BRIAR

Oh, I didn't know. I'm sorry.

Briar backs away.

DUSTY

Don't be. I'd like to go on a date with
you. In fact, let's call this a date.

Tray walks in and notices C.K.

> TRAY
> Where'd you get those shoes?

> C.K.
> You like 'em?

> TRAY
> Depends on what they cost. They look
> pretty expensive.

> C.K.
> They look good, though, huh?

> TRAY
> Stop fooling around. We've talked about
> this. We have to watch our expenses.

> C.K.
> Believe me, I did not distress our
> finances.

> TRAY
> Just tell me how much.

> C.K.
> Free.

> TRAY
> Free? How can you possibly get shoes
> like that for free?

> C.K.
> Don't worry about it. It didn't cost us
> anything. That was the issue, right?

> TRAY
> That *was* the issue, now tell me how you
> got those damn shoes.

> C.K.
> You're just going to have to trust me on
> this one.

C.K. starts walking out.

> TRAY
> This is really not working for me.

> ADLER
> Can we talk?

> MING
> I don't think it's a good idea.

> ADLER
> Hear me out. I'm in a different place.
> I've figured things out.

> MING
> I'm glad, but it's too late.

> ADLER
> Too late for what?

> MING
> For us.

Adler takes it hard, sighs deeply.

> ADLER
> Okay. I understand. I need to
> apologize, though, and tell you...
> well... I blew it. We had a chance for
> something good and I blew it.

> MING
> Why do you have to tell me this now?

> ADLER
> I know the timing sucks. I'm not trying
> to make this hard. I needed the time to
> figure things out.

> MING
> I didn't need you to figure things out
> now. You were making it easy for me to
> move on. Now this.

> ADLER
> Like I said, timing sucks, but I'm here
> now. Give me a chance.

Ming considers a long time.

> MING
> It's still too late.

Adler leaves, dejected. Ming clearly regrets it.

 MERRILL
 Oh jeez!

Merrill and Baley are both startled to see each other.

 BALEY
 Sorry, I really had no idea you were
 gonna be here.

 MERRILL
 I hadn't planned to be here.

 BALEY
 I've been trying to give you space.

 MERRILL
 I know and I appreciate it. Relax.
 It's not a big deal.

 BALEY
 Really? I thought—

 MERRILL
 Yeah, I felt that way for a while.

 BALEY
 So we're better now?

 MERRILL
 Better doesn't mean good.

 BALEY
 I got it. Still, I'm glad.

 MERRILL
 Look, the way things turned out...

 BALEY
 Yeah, I'm sorry. I really am.

 MERRILL
 I know. That's not what I'm getting at.
 I mean the ugliness... It doesn't really
 change all the good stuff.

 BALEY
 I'm glad you remember that stuff too.
 That's all I ever think about.
 Anyway... I'll... I'll leave you to it.

Baley makes a quick exit. Merrill sighs.

Ashley walks in, eyeballing Carlin.

 ASHLEY
 I know you've been up to something.

 CARLIN
 Up to? What does that mean?

 ASHLEY
 You've been poking around.

 CARLIN
 Poking? I've been sitting here. Am I
 not allowed here?

 ASHLEY
 You were in the cupboards and the
 drawers. Why?

 CARLIN
 I don't know what you're talking about.
 I was sitting here.

 ASHLEY
 So you didn't open any cupboards?

 CARLIN
 Are you accusing me of something?

 ASHLEY
 Answer the question.

 CARLIN
 No. You either trust me or you don't.
 I don't need to be interrogated.

 ASHLEY
 I don't trust you then. Now answer the
 question.

 CARLIN
 Okay, if that's how you are. I was
 hiding a present. Something Shane and I
 got for you.

 ASHLEY
 Oh. I... Really?

 CARLIN
 Do I need to prove it? Want to see it
 now? I know you don't trust me.

 SHILOH
 Did you threaten Lane?

 K.D.
 We got in a dumb, little beef. I
 straightened that fool out though.

 SHILOH
 Violent behavior is not okay.

 K.D.
 Yeah, well, don't do it then.

 SHILOH
 No. *Your* violent behavior is not okay.
 This is a *we* thing not a *you* thing.

 K.D.
 You can't be telling me not to stand up
 for myself.

 SHILOH
 Big difference between standing up for
 yourself and threatening. Now do you
 care about us?

 K.D.
 You know I do.

 SHILOH
 All I'm saying is that we both have to
 compromise a little. This is something
 I need you to compromise on.

 K.D.
 How are you compromising here?

 SHILOH
 What did we do last night?

 K.D.
 Throwin' that at me again, huh?

 SHILOH
 That's a big deal for me. You know it
 is. You like it... no more violence.

 K.D.
 Yeah, yeah. You win.

K.D. only play sulks, shooting Shiloh a sly smile.

Kennedy enters, tries to ignore Ainsley.

 AINSLEY
 What are you doing here?

 KENNEDY
 None of your business.

 AINSLEY
 We don't want you here.

 KENNEDY
 We?

 AINSLEY
 Yeah, *we*.

 KENNEDY
 I think I'd like to hear that from
 Jordan for myself.

 AINSLEY
 Jordan doesn't want to see you.

 KENNEDY
 Really? You speak for Jordan now?

 AINSLEY
 You know how things ended last time you
 saw each other.

 KENNEDY
 What do you know about it?

 AINSLEY
 I know all about it.

 KENNEDY
 Jordan told *you*?

 AINSLEY
 Jordan tells me everything.
 Everything... and I think you better
 leave us alone.

This takes the air out of Kennedy who begins to leave.

 KENNEDY
 Tell Jordan... Actually, forget it. You
 know what? I'm wishing you guys the
 best. Actually... no, I'm not.

 PALMER
 I don't want anyone to get hurt.

 RORY
 That's not our problem.

 PALMER
 Okay, I don't want to hurt anyone.

 RORY
 Then what are you doing here?

 PALMER
 I thought it would be different.

 RORY
 This is how it is. Do I need to worry
 about you now?

 PALMER
 No, I'm okay.

Uncomfortable silence as Rory sizes up Palmer.

 RORY
 Look it's not our decision. We just do
 what we're told, right.

 PALMER
 I guess...

 RORY
 If we don't do it, somebody else will.

 PALMER
 Yeah... Okay...

Another long silence as Palmer sizes up Rory.

 PALMER
 That stuff works for you?

 RORY
 No, not really, but what choice is there
 at this point?

 RORY
 I suppose, but thanks for being honest.

They share a brief smile.

Raegan and Mace sit awkwardly across from each other

 RAEGAN
We need to work together. We're part of
a team.

 MACE
I'm pretty sure we work together.
Aren't we working together right now?

 RAEGAN
We work in the same room.

 MACE
...Together.

 RAEGAN
Not exactly.

 MACE
Look I don't know where you're trying to
go with all this. You trying to make
trouble for me or something?

 RAEGAN
No. I guess, I thought I could make
things better.

 MACE
Things are good. Be happy. Don't stir
the pot. Things might get worse.

 RAEGAN
Is that... a threat?

 MACE
I knew it. This is a set up, right?
You're going to run to Alex with all
this aren't you?

 RAEGAN
No, no. I swear. I was just...

 MACE
What?

 RAEGAN
Nothing. Forget I ever said anything.
Sorry.

Mace smiles for the first time. Leaves.

Alton walks in and considers Francis for a long moment.

> ALTON
> Whatta yah watchin'?

> FRANCIS
> Hmmmm... Some... thing.

> ALTON
> Really? You won't miss anything if we
> go out then.

No response.

> ALTON
> C'mon, let's go!

> FRANCIS
> Thanks. I'm good.

> ALTON
> No, you're not. When was the last time
> you were out?

> FRANCIS
> I dunno. What's today?

> ALTON
> Yeah... not good. We're getting you
> out.

> FRANCIS
> Really, I'm okay. Don't make a thing
> out of this. I'm just in a funk.

> ALTON
> No. It's called a depression.

> FRANCIS
> What are you a psychologist now?

> ALTON
> No, I've just been depressed before.

> FRANCIS
> You?

> ALTON
> Yes. C'mon, I'll tell you about it.

Alton extends a hand to help Francis up. After a moment,
Francis takes it.

 SACHA
Me and Palmer are moving in together.

 WEI
Really!? That's exciting. Congrats!

 SACHA
Thanks. I am excited.

 WEI
Wow. So, when are you moving out?

 SACHA
We're moving in here.

 WEI
Here? All three of us?

 SACHA
No. Just me and Palmer.

 WEI
Uhhh... You can't ask me to leave. We
found this place together.

 SACHA
I'm not asking.

Sacha looks daggers at Wei who wilts.

 WEI
But I love this place.

 SACHA
I'll let you know if things don't work
out for us.

 WEI
I can't believe this. You just expect
me to move out?

 SACHA
This Saturday.

 WEI
I... But... Uh... We... Ugh.

 SACHA
Saturday. Understand? It's been real.

Sacha leaves smiling.

 MURPHY
I wanted to thank you for yesterday

 PAU
Thank me? Thank you.

 MURPHY
I really don't know what I would have
done without you.

 PAU
You would have been fine, I'm sure, but
it meant a lot to me.

 MURPHY
You're the best.

 PAU
No, seriously, you're the best.

 MURPHY
You know that's not true. You're just
too good a person to admit it.

 PAU
I am not that good a person.

 MURPHY
Oh? Well, I am a really *bad* person.

 PAU
I am completely worthless, really, the
worst. You have no idea.

They both take a breath sensing the awkwardness.

 MURPHY
Tell you what, let's call it a draw.

 PAU
Great idea, you're the-

 MURPHY
Draw!

 PAU
Right. *We're* the best?

 MURPHY
Yeah. Or the worst, either way.

Shell walks in and sees that Zo is upset.

 ZO
We've been broken into.

 SHELL
You mean robbed? Is something missing?

 ZO
Just the TV, I think.

 SHELL
The TV! Have you called the police?

 ZO
No.

 SHELL
Okay, I'll call.

 ZO
No. Don't. I think... it may have been
Jay.

 SHELL
Jay? Wow. We need to tell the police.

 ZO
Jay is... sick. You know that. I can't
rat Jay out to the police.

 SHELL
Rat? Jay robbed us and we're out a TV!
Maybe the police can get it back.

 ZO
No! No. I'll get us a new TV... out of
my pocket. A better one.

 SHELL
You're being foolish. What's to stop
Jay from stealing that one too?

 ZO
I'll take that chance. You know I can't
just give up on Jay.

 SHELL
You're a good person and I respect that,
but I just better not catch Jay in here.

Vonn walks in examining Leighton.

> VONN
> Were you drinking?

> LEIGHTON
> Really not your business.

> VONN
> Wow.

> LEIGHTON
> Wow, what?

> VONN
> You were two months sober.

> LEIGHTON
> Yeah. So?

> VONN
> So you were doing good.

> LEIGHTON
> Doin' better now.

> VONN
> No, no. You know where this ends up.
> You've been down this road.

> LEIGHTON
> My problem, isn't it? Who cares anyway?

> VONN
> I care.

> LEIGHTON
> You care?

Long pause.

> VONN
> I care. I did care. I was starting to
> care, but I can't do this. I thought
> this was over.

> LEIGHTON
> You should have said, it would have
> helped. It still could help, if...

Leighton smiles. After a moment, Vonn smiles too.

Vivien watches Talib for a moment before speaking.

> VIVIEN
> Is there something wrong with you?

> TALIB
> Oh, I'm fine.

> VIVIEN
> You're not walking right. You're hurt.
> What happened to you?

> TALIB
> Nothing. I told you, I'm fine.

> VIVIEN
> Were you in a fight? Don't lie to me.

> TALIB
> Just a little scuffle.

> VIVIEN
> What is wrong with you? How old do you
> think you are? You can't just go around
> getting in fights at your age.

> TALIB
> I wasn't trying to get in a fight. It
> kind of couldn't be avoided.

> VIVIEN
> Couldn't be avoided? How about walking
> away?

> TALIB
> Not after what this fool said.

> VIVIEN
> What could they possibly say, that you
> couldn't just ignore?

> TALIB
> They said... you were gay.

> VIVIEN
> Well, I'm flattered, I guess, that you
> thought you should defend me, but you
> should probably know, I am gay.

Talib looks up surprised.

Blake approaches Adin, trying to be casual.

> BLAKE
> Hey!

> ADIN
> Uh... Yeah, hey. Have we...

> BLAKE
> At the beach, two weeks ago.

> ADIN
> Right. What are you doing here?

> BLAKE
> Just hangin' out.

> ADIN
> Do you go to school here?

> BLAKE
> Uh... No, actually.

> ADIN
> So what are you doing here?

> BLAKE
> I won't lie. I was hoping to run into you.

> ADIN
> And... how did you know I went here?

> BLAKE
> You mentioned it at the beach.

> ADIN
> No... I don't think I did.

> BLAKE
> Maybe it was your friend mentioned it, I
> don't know. Not trying to freak you
> out. Kind of hoping you'd be flattered.

Adin considers for a moment.

> ADIN
> I might be a little flattered.

They share a smile.

 MAX
You're that smart kid, right?

 LEE
What?

 MAX
From Calc, kid with all the answers.

 LEE
I was just... good in that class, I
guess.

 MAX
Still makes you smart. Not an insult,
you know?

 LEE
Right. Thanks?

 MAX
I'm Max.

 LEE
Lee.

 MAX
So, math major?

 LEE
No. Biology.

 MAX
How are you at that?

Lee shrugs.

 MAX
Ever get a "B" in a major course?

Lee shakes his head "no".

 MAX
I thought so. See if I was smart, I
wouldn't be shy about it. When you got
it flaunt it, right?

 LEE
So... what are you flaunting right now?

MILLER
Are you cheating on Reed?

DARBY
What business is that of yours?

MILLER
I care about Reed.

DARBY
That's nice for you and Reed, but
doesn't mean I have to listen to your
crap.

MILLER
But Reed does listen to me and you
couldn't be acting more guilty.

DARBY
Tell Reed whatever you want. It doesn't
matter to me.

MILLER
Wow. I'm just worried about my friend.
That counts for nothing with you?

DARBY
Maybe it would if I didn't dislike you
so much.

MILLER
What did I ever do to you?

DARBY
Accuse me of cheating...

MILLER
Yeah, but...

DARBY
But what? Make your accusations. See
who Reed believes. The sooner Reed
pushes you away, the better.

Darby starts to leave.

MILLER
You're unreal.

DARBY
Oh, I'm real. You'll see.

Manning walks in and approaches Sheridan.

> MANNING
> Did you talk to Shea about me?

> SHERIDAN
> You asked me to didn't you?

> MANNING
> Yeah, but Shea didn't give me the job.

> SHERIDAN
> I didn't know, sorry to hear it.

> MANNING
> What did you say to Shea about me?

> SHERIDAN
> Do you think I told Shea something bad
> about you?

> MANNING
> I don't know what you told Shea, that's
> why I asked.

> SHERIDAN
> I told Shea to hire you, that you were
> great.

> MANNING
> That's all? Shea didn't ask about my
> weaknesses or something?

> SHERIDAN
> Yeah, but I minimized that.

> MANNING
> Minimized what?

> SHERIDAN
> That you can be pushy.

This chastens Manning.

> MANNING
> Pushy?

> SHERIDAN
> Yeah. I minimized it though. Maybe you
> should think about minimizing it too.

Bali walks up to Dorian cautiously.

> BALI
> What are you doing here?

> DORIAN
> Just visiting.

> BALI
> Why? Why now? What do you want?

> DORIAN
> Nothing. Just saying "hi".

> BALI
> Don't try to screw things up with me and
> Goldwyn.

> DORIAN
> Why would I want to do that?

> BALI
> Because you're a notoriously bad loser.

> DORIAN
> I lost?

> BALI
> If you're trying to rattle me, you're
> doing a good job, but I hope that's all
> your trying to do.

> DORIAN
> Or...?

> BALI
> You can answer to Goldwyn.

> DORIAN
> Really?

> BALI
> By the way, did I mention that Goldwyn's
> a cop?

> DORIAN
> Like I said... just saying "hi".

Dorian smiles thinly and walks away. Bali exhales.

Tiger walks in and is stopped short by Jaden's angry look.

> TIGER
> What's wrong?

> JADEN
> T.J. saw you with Robin last night.

> TIGER
> Don't start this.

> JADEN
> Tell me you weren't with Robin then.

> TIGER
> I'm allowed to be with Robin.

> JADEN
> What!?

> TIGER
> You know what I mean. I'm allowed to be
> seen with people in public.

> JADEN
> Yeah, but how come I have to hear about
> it from T.J.?

> TIGER
> I was out. I saw a lot of people. Am I
> supposed to tell you everyone I saw?

> JADEN
> People like Robin, yeah.

> TIGER
> People like Robin?

> JADEN
> You know...

> TIGER
> No. I don't know. What are you saying?

> JADEN
> Oh... You don't know. Never mind then.

Tiger is relieved for a moment.

> TIGER
> Wait, what don't I know about Robin?

Abbel wanders in. Lane looks up excited.

 LANE
What happened last night? I waited up.

 ABBEL
And?

 LANE
You were going to tell me about the
date.

 ABBEL
I was?

 LANE
Well don't you usually?

 ABBEL
I have before. Does that mean I'm
obligated to forever?

 LANE
What? Did something bad happen?

 ABBEL
No.

 LANE
Is that why you don't want to tell me?

 ABBEL
Look, this is getting weird.

 LANE
I'm sorry about whatever happened. You
will feel better if you talk about it,
though.

 ABBEL
Okay, this needy-vicarious thing, not
working for me.

 LANE
Oh. Okay, I'll... I'll be here if you
change your mind.

 ABBEL
Great to know

Abbel is a little regretful watching Lane leave sadly.

 REESE
We should do something this weekend.

 TAY
Gotta work, pretty behind.

 REESE
No problem. That's cool.

 TAY
No. It's not. What happened to me? I
used to be crazy, spontaneous, fun. I
used to really live. I used to be free.

 REESE
Everyone grows up. Can't be avoided.

 TAY
But I don't wanna be this way.

 REESE
What's the alternative?

 TAY
You're doing something fun, aren't you?

 REESE
That's me. So what?

 TAY
Why not me? It's up to me, isn't it?
I'm not a damn prisoner. Screw all this
work. Let's do something fun.

Reese considers.

 REESE
 No.

 TAY
What do you mean, no?

 REESE
You're no prisoner. You made a decision.
You just made the right decision. You're
smarter than me. You know that, don't you?

 TAY
Okay... yeah. Thanks. Have fun, I
guess.

> NICKY
> What happened to you?

Masyn has a black eye and several bruises.

> MASYN
> Nothing.

> NICKY
> Seriously. What happened?

> MASYN
> I fell. Don't make a thing out of it.

> NICKY
> It is a thing. I don't need to make it
> into a thing. Now what really happened?

> MASYN
> I told you.

> NICKY
> There's no way you could get bruises
> like that from falling. There's only
> one way to get bruises like that, so
> tell me who gave them to you.

> MASYN
> Leave me alone. Don't push me.

> NICKY
> I'm not trying to push you. I'm not the
> one who did that to you.

> MASYN
> You don't understand. You don't know
> anything. You don't want to know.

> NICKY
> Listen to me. I know that you don't
> deserve that. No one does.

> MASYN
> What about the person I was fighting!?
> Did they deserve it!? At least I could
> walk away. Why don't you go worry about
> them.

Nicky is stunned.

MERCE
What was that?

LERNER
I don't know, the wind, the trees.

MERCE
What makes you so sure?

LERNER
It's a windy night and there are a lot
of trees out there.

MERCE
That doesn't mean it couldn't be
something else.

LERNER
What?

MERCE
Someone trying to get in.

LERNER
You've got no reason to think that, do
you? On the other hand, there's a lot
of trees out there.

MERCE
It doesn't sound like a tree to me. It
sounds like prying on wood, like someone
with one of those pry bars working on a
door or a window, but they're smart and
only do it when the wind kicks up.

Lerner is creeped out, but shakes it off.

LERNER
You can't just imagine the worst case
every time you hear something you're not
sure of. You'll drive yourself crazy.
Promise me you'll calm down.

MERCE
You're right, you're right, I will.

They both settle back, but are both still listening.

LERNER AND MERCE
What was that!?

 KERRY
I really don't know if I'm up to dealing
with your parents this weekend.

 JAY
What!? You already said you would go.

 KERRY
I definitely never said for sure.

 JAY
Don't do this. It's important to me.

 KERRY
I'm not saying you shouldn't go. You
should for sure. I'll get caught up on
some stuff here.

 JAY
It's important to me that you be there.

 KERRY
You say that, but you'll have your
sister and your brothers there.

 JAY
I guess, but it's not the same. I want
you there.

 KERRY
Okay, you admit it's a *want* case not a
need case. So... what's it worth to
you?

 JAY
Uh-oh... Why?

 KERRY
Let's make a deal.

 JAY
What?

Kerry beckons Jay over with a finger and whispers in Jay's
ear. Jay's is a little shocked.

 KERRY
Deal?

 JAY
Deal. But... I'd have done that
anyway.

> RYAN
> You remind me of a bee. I think, I'm
> gonna call you Bumble.

> JAMMER
> Yeah, actually, I already have a
> nickname, it's Jammer.

> RYAN
> Your new nickname is Bumble.

> JAMMER
> I think I'll just stick with the old
> one.

> RYAN
> You not listening?

> JAMMER
> Yeah. I just prefer you call me Jammer.
> Everybody calls me Jammer, okay?

Ryan walks up closer to Jammer.

> RYAN
> You are not listening. Your name is
> Bumble now. Understand?

> JAMMER
> I... Yeah... Got it... That's fine.

Jammer tries to leave.

> RYAN
> Now say it, what's your name?

> JAMMER
> What? Really?

> RYAN
> What's your name?

A long pause.

> JAMMER
> Bumble.

> RYAN
> That's what I thought.

Jammer leaves, Ryan smiles, satisfied.

Presley charges in.

> PRESLEY
> Where are my headphones?

> WING
> What? I don't know.

> PRESLEY
> Are you sure?

> WING
> Why would I know?

> PRESLEY
> You borrow them all the time.

> WING
> Not all the time, maybe twice.

> PRESLEY
> Three times that I know of.

> WING
> Those aren't even the headphones that
> are missing.

> PRESLEY
> How do you know which headphones are
> missing?

> WING
> I... I saw the ones I borrowed just
> now.

Wing starts looking around the room.

> PRESLEY
> You saw those headphones just now?
> Those headphones that are in my car?

Wing stops looking around the room.

> PRESLEY
> Now... where are my headphones?

> WING
> Maybe they're both in your car?

Wing smiles weakly. Presley moves toward Wing and Wing takes
off running.

CARTIER
I don't think I can do this anymore.

DARIEN
This?

CARTIER
Us. Our relationship.

DARIEN
You don't love me?

CARTIER
I do, but we're not going anywhere.

DARIEN
Where are we supposed to go?

CARTIER
Anywhere. Move in, meet parents, get
engaged, progress, commit.

DARIEN
Ahh... this again.

CARTIER
No. Not "this again". I'm not
complaining. I'm way past that. I'm
just telling you why it's over.

DARIEN
So you're threatening me this time?

CARTIER
No. I'm not threatening. It's over
now. Understand? End of story.

DARIEN
I thought you loved me.

CARTIER
It takes more than that. I don't think
you'll ever understand. This
conversation kind of proves it. I
should thank you for it.

Cartier leaves.

DARIEN
Don't thank me, I do it because I love
you.

Shashi walks in with purpose.

> LORNE
> Uh oh, what's up your butt?

> SHASHI
> I know about the weed, but what else?

> LORNE
> Why are you always on my back? I've
> seen you smoke out plenty.

> SHASHI
> Weed's as far as I go. What about you?

> LORNE
> Here comes the lecture...

> SHASHI
> Just tell me, because some of this stuff
> can really mess you up.

> LORNE
> So not interested in your sanctimonious
> crap.

> SHASHI
> I'm not trying to mess with you. I
> care, you know I do. You can get hurt
> going down this road.

> LORNE
> That's nice, I almost believe that, but
> really, I'm fine.

> SHASHI
> I don't think so. I found a needle.

> LORNE
> So... What now? You gonna tell me how
> you were right about the whole slippery-
> slope thing?

> SHASHI
> No. That's so not what's going on here.
> I want to help... No judgment... I
> swear. Please, will you let me help?

Lorne won't make eye contact, but eventually looks up at
Shashi. They share a look and Lorne nods "yes".

 JESSIE
Why are you here? You weren't invited.

 EDEN
I'm here with Avery.

 JESSIE
Avery, really? You move fast.

 EDEN
Yes, well, Avery asked. I didn't come
here for a confrontation with you.

 JESSIE
Really? I can't imagine what you
expected then.

 EDEN
I guess I thought you were a more
gracious loser.

 JESSIE
Okay. You better just leave before this
gets ugly.

 EDEN
Ugly... Wouldn't want that.

Eden starts to go.

 JESSIE
Wait. Maybe you should stay. Everybody
here knows what you did. See how it
goes for you.

 EDEN
You think that's a problem for me?
You're wrong. I'm good with what I did.

 JESSIE
Yeah. Well, see what they think of it.

 EDEN
Fine by me. I'll fill them in on a few
things they might not know.

 JESSIE
Maybe you should go.

 EDEN
Before it gets ugly, right?

Lynne walks in on Charlie who watches TV.

> LYNNE
> Why do you watch this crap?

> CHARLIE
> It's mindless fun.

> LYNNE
> There's sooo much better stuff on.

> CHARLIE
> I don't know. Is it really that much
> better?

> LYNNE
> Yes. It is. This is total crap.

> CHARLIE
> Eh... different strokes.

> LYNNE
> Don't make it sound like a matter of
> taste. What you watch is crap. I do
> not watch crap like this.

> CHARLIE
> You just don't realize that what you
> watch is crap.

> LYNNE
> I don't watch crap.

> CHARLIE
> Sports is so, so informative, so
> edifying, such great art...

> LYNNE
> It's not like this reality stuff.

> CHARLIE
> How exactly? Tell me what is so
> important about sports.

Lynne wants to respond, but is stumped.

> CHARLIE
> Yeah, that's what I thought. Now do me
> a favor, and keep your stupid judgments
> to yourself. I'm trying to enjoy this.

Noel and Sammie sit awkwardly at a table.

> NOEL
> The obvious question is why us?

> SAMMIE
> What do you mean?

> NOEL
> Why did Jean set us up?

> SAMMIE
> Ah, right. Good question. Must be a
> reason, something in common.

> NOEL
> You much of a reader?

> SAMMIE
> Not really. Like sports?

> NOEL
> More into movies.

> SAMMIE
> Politically active?

> NOEL
> No, but I volunteer for a children's
> charity.

> SAMMIE
> Hmmm... Gotta be something. You like
> to be stalked? I like to obsess over
> ex-lovers. You know, follow them
> around, go through their trash. Into
> that?

> NOEL
> Oh yeah, as long as it ends in gunplay.
> Though knives are always fun.

They both laugh.

> SAMMIE
> So then, messed-up sense of humor, is
> that the connection?

> NOEL
> Oh, you were joking?

 VANDY
Gimme yer digits.

 DANA
What?

 VANDY
Your number, let's have it.

 DANA
Are you kidding?

 VANDY
Why not?

 DANA
Because I don't know you, and that's
probably the worst line ever.

 VANDY
Okay, but besides the obvious. Is there
a problem with the looks? Plus I'm real
smart: pre-med right now. Serial
monogamist, too.

 DANA
If you're so smart, why the bad line?

 VANDY
I did the math and decided there is no
such thing as a good line. Is there?

 DANA
Okay, I can see you've thought this all
out, but tell me honestly, has this ever
actually worked?

 VANDY
Well... If it works here that's all
that matters.

 DANA
I'm kind of suspecting you just came up
with this as a way to meet me.

 VANDY
Maybe...

Dana considers. Vandy waits, patient and confident. Dana
takes Vandy's phone and types into it. Vandy smiles.

 175

Kerrigan and Pike walk in.

KERRIGAN
So happy to be home.

PIKE
How great for you.

KERRIGAN
Really, you're not a little glad to be
out of there?

PIKE
No. I was having a great time.

KERRIGAN
Oh. Why'd you leave then?

PIKE
You were so miserable, you were ruining
it for me.

KERRIGAN
Sorry. Party's like that are just not
my scene.

PIKE
How would you know? It's not like you
even try. Honestly, did you try?

KERRIGAN
Not really... No.

PIKE
Didn't you know it was important to me?

KERRIGAN
Well, yeah, I guess.

PIKE
Then why wouldn't you at least try?

KERRIGAN
I... I guess I wasn't thinking about it
that way.

PIKE
Yeah. Maybe you better start.

Pike walks out leaving Kerrigan miserable.

 REY
You were pretty plowed last night.

 STATLER
Yeah, good times.

 REY
Seriously, though, I'm starting to
worry. You are drinking a lot.

 STATLER
Wait, are *you* criticizing *my* drinking?

 REY
I'm not criticizing. I'm concerned.

 STATLER
But you? You drink all the time.

 REY
We're not talking about me, we're
talking about you.

 STATLER
Yeah, but it's *you* talking about me.

 REY
Okay, maybe I'm not the right messenger,
but maybe I am. You really want to head
down the path I'm on?

 STATLER
You're having a good time. Don't act
like you're miserable.

 REY
There's a lot more to life than having a
good time. What about your hopes, your
dreams, your future? I mean... What
kind of future do you think I have?

 STATLER
You'll be... I mean... You're not...
I... I don't know what to say.

Rey takes a long time to respond. The pause is awkward

 REY
Just say you'll ease up on the drinking.

Brogan rushes in.

> BROGAN
> I got it, I figured out who we can rob,
> Mrs. Wilson.

> LINDSAY
> Mrs. Wilson? Why her?

> BROGAN
> Think about it. She's perfect. Lives
> alone. Can't have any security in that
> old house. Has jewelry for sure and who
> knows what else.

> LINDSAY
> But she's just an old lady.

> BROGAN
> Exactly.

> LINDSAY
> But she's nice. I don't think we should
> rob her. She's always been nice to me.

> BROGAN
> Well, we gotta rob somebody. Who do you
> wanna rob, then?

> LINDSAY
> I don't know... bad people, criminals
> maybe.

> BROGAN
> Criminals? What criminals do we know?

> LINDSAY
> None, really. I guess, I didn't really
> think it through that much.

> BROGAN
> Good thing I did, then. Now, you
> gettin' cold feet? I need to know. You
> in or you out?

> LINDSAY
> I... I'm in, I guess... as long as it's
> not Mrs. Wilson we rob.

Brogan leaves in disgust.

 KRIS
You have a problem with me?

 PILER
What makes you say that?

 KRIS
The attitude... the snide comments.

 PILER
Snide?

 KRIS
Snide, smart-ass, whatever.

 PILER
No sense of humor, huh?

 KRIS
Oh it's all good fun then, huh? The
crack about my IQ?

 PILER
When was this?

 KRIS
I don't know, a couple weeks ago.

 PILER
Really? You're obsessing over some
offhand comment I made weeks ago and I'm
the one with the problem?

 KRIS
It's not just the comments, it's the
tone. Like right now.

 PILER
Oh? And what's happening right now?

 KRIS
Well there's the sarcasm, and the
patronizing, and of course, the overall
tone of superiority.

 PILER
You know, I was wrong to make that crack
about your IQ. Your problems are
emotional, not intellectual.

Piler leaves angry. Kris stews.

 GERRY
I heard something!

Gerry and Hiro both pause, listening. Hiro whispers.

 HIRO
You sure you heard something?

 GERRY
Yeah. It was like keys jangling...
I think.

 HIRO
Keys? I know you're nervous. Are you
sure your nerves aren't playing tricks
on you?

 GERRY
I don't know... maybe. I am nervous.

 HIRO
Don't sweat it. Just hang in there.
We'll be laughing about this when we're
counting our money later, okay?

 GERRY
Yeah. Okay. Wait. You hear that?

 HIRO
What?

 GERRY
You don't hear that? No way that's my
nerves.

 HIRO
You mean that siren? That's like on the
other side of town. Look you have got
to calm down, otherwise we should just
scrap this whole thing.

 GERRY
Is that still an option?

 HIRO
Say the word.

 GERRY
Uhh... Well... Wait! You hear that?

 HIRO
Yeah. This was a bad idea. Let's go.

 BUTLER
You need help. We need to get you help.

 NEHAL
Help for what?

 BUTLER
Please don't do this. You know.

 NEHAL
All I know is that there's things about
me you don't like that you want to fix.

 BUTLER
C'mon, you get so high, but you get *so*
low. It's not good. You know you're
not happy.

 NEHAL
Who's happy all the time? Yeah, I get
down. Who doesn't get down?

 BUTLER
But you get *so* down. It's not healthy.

 NEHAL
Moods aren't healthy? It's healthier to
take drugs the rest of my life that keep
me from having moods.

 BUTLER
Not take away your moods, just moderate
them. You know how bad it gets. Do you
know what that's like for me?

 NEHAL
So is this help for *me* or *you*?

 BUTLER
That's not it. You can be a happier,
better person. Don't you want that?

 NEHAL
You know, I'm not hoping for a medically
altered version of you, I love *you*. Why
can't you just love *me*?

Nehal leaves angry. Butler sags.

 BUTLER
That's not how it is.

181

George enters, observes Cheche for a moment before speaking.

> GEORGE
> You need to get back out there.

> CHECHE
> I don't know. Need is a strong word.

> GEORGE
> How long's it been?

> CHECHE
> Since the break up?

> GEORGE
> How 'bout since the last time you were
> on a date?

> CHECHE
> I don't even know.

> GEORGE
> My point, exactly. What about it?

> CHECHE
> It's just not that easy. You gotta go
> out, you gotta meet people. It's all
> such a scene. I don't know...

> GEORGE
> How about me, then?

> CHECHE
> To go out? On a date?

> GEORGE
> Yeah. Why not?

> CHECHE
> As just like, a practice date?

> GEORGE
> No, a real date. It's something I
> wanted for a long time, but I wanted to
> make sure you were ready.

Cheche considers for a long moment, then smiles.

> CHECHE
> I'm ready.

Booker approaches Eton.

> BOOKER
> You need to leave.

> ETON
> What?

> BOOKER
> Leave. Get out of here.

> ETON
> I've got a right to be here.

> BOOKER
> Not while I'm here.

> ETON
> Well, sorry, I'm not going anywhere.

> BOOKER
> Oh, you'll go, one way or another.

> ETON
> What? Are you threatening me?

> BOOKER
> Yes.

Long silent standoff.

> ETON
> You are just a messed up human being.
> You are not worth my trouble.

Eton backs down, starts to go.

> BOOKER
> That's what I thought.

Eton stops.

> ETON
> Don't get all proud. You've got nothing
> to be proud of—nothing.

> BOOKER
> Too much talk, not enough walk.

Booker takes a few steps toward Eton and Eton hurries away.

183

Trace walks in, sees Indy, and does a double take.

> TRACE
> You need to see a doctor. You look
> terrible.

> INDY
> I'll be fine. I'm just a little sick.

> TRACE
> A little? Are you kidding?

> INDY
> Seriously, it's not as bad as I look.

> TRACE
> What does that even mean? Are you even
> thinking straight? What's wrong with
> you? Why won't you see a doctor?

> INDY
> I hate doctors. Not just hate... I get
> like pathologically anxious. It's bad.

> TRACE
> I'll go with you.

> INDY
> I... don't think so. Thanks, best just
> to let me rest.

Trace considers for a moment.

> TRACE
> I know, we'll go see my uncle. It's a
> bit of a drive, but he's really cool for
> a doctor and will be really sensitive
> about your anxiety and everything.

> INDY
> I don't know...

> TRACE
> He won't charge either. Never does.

> INDY
> If he's cool... Maybe...

Trace hides a smile.

Tate and Deniz are sitting not too far from each other.

> TATE
> You come here a lot.

> DENIZ
> Oh? Yeah... You look familiar too.

> TATE
> You read a lot of art books, right? I'm
> not watching you or anything... I only
> noticed because I like art books.

> DENIZ
> It's okay if... I mean I didn't think
> you were... watching... me.

> TATE
> No... it was... the books.

> DENIZ
> Yeah. I like... pre-impressionists.

> TATE
> I know. I mean... that's why I noticed.
> You had Whistler one time... and Turner.

> DENIZ
> You like Turner?

> TATE
> I love Turner. When I saw you with that
> book, I... almost said something to you.

> DENIZ
> I... wish you had.

> TATE
> Sorry... I'm shy.

> DENIZ
> I am too. You said something this time.

> TATE
> I did.

> DENIZ
> I'm glad.

They share an awkward, but warm smile.

HILARY
I will never trust you again.

MARAM
What? Why? What's going on?

HILARY
You told Sacha about me and Hollis,
didn't you?

MARAM
I most certainly did not.

HILARY
Well you told somebody who told Sacha.

MARAM
I told no one. Didn't you make me
promise? How can you even think I would
do that?

HILARY
Who told Sacha then?

MARAM
How should I know. If you didn't tell
anyone else, who did Hollis tell?

HILARY
Hollis wouldn't say anything.

MARAM
Did you try asking Sacha?

HILARY
No, I didn't actually talk to Sacha.

MARAM
How do you know Sacha knows then?

Long pause from Hilary

HILARY
It was more of a look Sacha had.

MARAM
So... You came in here and accused me
of violating your trust based on a look
you think Sacha gave you?

Hilary can't respond. Maram leaves angry.

Kelsey comes in looking desperate.

> KELSEY
> Tell me where you hid that chocolate.

> QI
> What? It hasn't even been a week.

> KELSEY
> I don't care. I need it now.

> QI
> You know you specifically warned me that
> you would try to get it from me early.

> KELSEY
> Yeah, well forget that.

> QI
> I don't think I can. You made me
> promise, and I won't let you down.

> KELSEY
> How are you letting me down? It's *me*
> asking you for it now.

> QI
> But you warned me about you. I know you
> remember. This was—what, five days ago?

> KELSEY
> Yes, yes. I remember. I just didn't
> think you'd take it all so seriously.

> QI
> Oh! Are you saying it was all a joke?

> KELSEY
> Yes... That's exactly what I'm saying.
> Ha, ha! Pretty funny, but not binding.

> QI
> Nice try.

> KELSEY
> Screw you! I'll just go buy more then.

Kelsey marches out.

> QI
> Yeah, good luck finding those keys.

Jackie and Indigo are having trouble making conversation.

> JACKIE
>
> You watch porn?

> INDIGO
>
> That's a little personal.

> JACKIE
>
> Too private, right? I understand. It's
> just something I wonder about.

> INDIGO
>
> You wonder about me watching porn?

> JACKIE
>
> No. I just wonder if people who watch
> porn imagine it's them in the porn.

> INDIGO
>
> I never really thought about that.

> JACKIE
>
> So you don't watch?

> INDIGO
>
> Everybody... or at least most people...
> I mean, it's not that unusual.

> JACKIE
>
> How much do you watch?

> INDIGO
>
> Yeah, not comfortable with this.

> JACKIE
>
> Okay, not you, but do you think people
> imagine themselves in the porn?

> INDIGO
>
> I don't know... I guess... yeah.

> JACKIE
>
> But don't some guys watch two girls and
> gay guys watch straight porn? How does
> that work? What do you watch?

Indigo sighs, regroups.

> INDIGO
>
> You watch sports? What's your team?

 CHAO
What time did you get home last night?

 MERCE
I don't know, after midnight, I guess.

 CHAO
Wow. You work too hard.

 MERCE
That's what it takes to get ahead.

 CHAO
And what do you get if you get ahead?

 MERCE
Promotion, success.

 CHAO
And what's the point of that?

 MERCE
Money, security.

 CHAO
Great. What are you gonna do with all
this money?

 MERCE
I get your drift. Stop trying to be all
coy and superior. I'm working hard now
so I don't have to work as hard later.
Plenty of time for fun and relationships
and all that good stuff later.

 CHAO
Sorry, I see now that you got it all
figured out, so I'll just take my lazy
ass back to bed. Don't want Pat getting
lonely there.

 MERCE
Pat? You and Pat? But you knew I liked
Pat.

 CHAO
No time for that now, though, right?

Chao walks out, leaving Merce to stew.

Tyler walks in. Surjeet looks up.

 SURJEET
 I heard a bunch of you went to the
 movies last night.

 TYLER
 Yeah, it was pretty good.

 SURJEET
 Yeah? I was here.

 TYLER
 Oh, I didn't know.

 SURJEET
 It's okay, I'd appreciate a call is all.

 TYLER
 Sure.

 SURJEET
 So you'll call me next time?

 TYLER
 I'll try to remember.

 SURJEET
 That seems a little noncommittal.

 TYLER
 Sorry, you know, something comes up, you
 make calls, there isn't a list...

 SURJEET
 I guess.

 TYLER
 Look, it's nothing personal. Don't take
 it that way.

 SURJEET
 Too late.

 TYLER
 Oh? Well... do take it personal then,
 but this is exactly why some people
 don't want you included.

Tyler and Surjeet stare at each other a long moment before
Tyler walks out.

Xander approaches but Harmon is too distracted to notice.

 XANDER
 You're a hottie!

Harmon looks around not sure who Xander is talking to.

 HARMON
 What?

 XANDER
 You. You're a hot-tie.

 HARMON
 I don't... know you.

 XANDER
 I didn't say you were an old friend or
 even a good person. I said you were a
 hottie. Do I need to know you for that?

 HARMON
 Okay, this is weird. I don't know what
 you want, but I don't like this.

 XANDER
 Wow. Really? Are you so not used to
 getting compliments? I don't believe
 that. So... is it me?

 HARMON
 Sorry, I just don't know you.

Xander extends a hand, smiling.

 XANDER
 Xander.

Harmon stares at the hand, considering it, but not taking it.

 HARMON
 No. Sorry. Not gonna do this.

 XANDER
 Really? Oh well, I guess. Total waste
 of hotness.

Xander walks away slowly, hoping for a change. Only after
Xander is gone, does Harmon look up, full of regret.

 DALLAS
 Here you go.

Dallas hands something to Zhi. Zhi looks at it.

 ZHI
 This is fifty bucks.

 DALLAS
 Congratulations, you can count.

 ZHI
 So what? We only got a hundred.

 DALLAS
 Ninety-eight. I rounded your half up.

 ZHI
 I could have gone to jail for fifty
 bucks?

 DALLAS
 Hey, nobody's going to jail.

 ZHI
 You promised hundreds with an "s".

 DALLAS
 Our timing was bad.

 ZHI
 No my timing was bad when I met you.

 DALLAS
 Hey, that's a little personal.

 ZHI
 How do I even know that's what we got?
 It sure looked like more last night.

 DALLAS
 So you don't trust me, that's it?

 ZHI
 You're a thief aren't you?

 DALLAS
 Hey, what are you?

 ZHI
 Exactly...

Pepper watches Logan, who paces nervously.

 PEPPER
 You're crazy.

 LOGAN
 Don't say that.

 PEPPER
 Then don't act crazy.

 LOGAN
 Really, it's not cool, considering my
 family history.

 PEPPER
 What family history?

 LOGAN
 My dad. He had some problems. He was
 institutionalized for a while.

 PEPPER
 No wonder you're so crazy.

 LOGAN
 I can't believe you.

 PEPPER
 Look, if you were stupid or ugly, I'd
 tell you that too, and your stupid, ugly
 family wouldn't change things.

 LOGAN
 Not cool. This is different.

 PEPPER
 How?

 LOGAN
 Okay, maybe it's not that different, but
 you can't be making fun of any of those
 things.

 PEPPER
 See, that's kinda crazy.

 LOGAN
 Well, I'd rather be crazy than a
 complete jerk.

Pyle types away on a phone. Jess sighs.

> JESS
> I'm lonely.

> PYLE
> What? Am I not right here?

> JESS
> Not really.

> PYLE
> What does that mean?

> JESS
> You're here, but you're not here.

> PYLE
> Now you're being crazy.

> JESS
> You're always on your laptop or staring
> at your damn phone.

> PYLE
> That doesn't make me not here. I could
> be anywhere, but I'm here.

> JESS
> I'm glad you're here physically, but
> that just makes it more frustrating that
> you're not here mentally.

> PYLE
> Well, I had no idea this was an issue.
> So what, do I not use my phone anymore?

> JESS
> You can use it, just talk to me
> sometime. Give me your full attention.

> PYLE
> You've got it now.

Pyle stares with exaggerated focus, makes Jess feel awkward.

> JESS
> Never mind, go back to your dumb phone.

> PYLE
> As long as you don't mind.

Kim walks in and sees Bruxie moping.

 KIM
 Still in the dumps?

 BRUXIE
 Shouldn't I be?

 KIM
 No, you shouldn't, not if you expect to
 get through this.

 BRUXIE
 Easy to say.

 KIM
 You're sick, you're not dead.

 BRUXIE
 Don't make it sound like I have a cold.

 KIM
 You're real sick, okay, but I am not
 playing the self-pity game with you.

 BRUXIE
 Suck it up, huh? That's your advice?

 KIM
 Yeah. What's the alternative? Lie down
 and let it defeat you?

 BRUXIE
 I'm just being realistic. Things aren't
 good. Why should I feel good?

 KIM
 You're not the only person in the world
 with problems. Look up from the floor,
 you might see people around you, people
 who care about you are hurting too.

 BRUXIE
 Oh, sorry, I see now that this is all
 really about you.

 KIM
 Me? Are you kidding? Your mom's sicker
 than you. Can't you be strong for her?

Kim storms out. Bruxie feels terrible.

Dillan observes Noor a long moment before speaking.

> DILLAN
> Look, I know you want to break up. It's
> pretty obvious.

> NOOR
> What do you mean?

> DILLAN
> Don't worry. I understand. It's okay.

> NOOR
> What are you saying? *You* want to break
> up?

> DILLAN
> No. I wish we could work things out,
> but I don't think you do.

> NOOR
> If you don't want to break up, why are
> you bringing this up?

> DILLAN
> I don't want this to be hard for you.

> NOOR
> So you want to break up... for me?

> DILLAN
> That sounds weird, but... I guess so.

> NOOR
> Jeez, you may be the nicest person I was
> ever with.

> DILLAN
> Thanks.

> NOOR
> Makes it hard to break up with you.

> DILLAN
> I'm not trying to make it hard.

> NOOR
> I know, too nice for that. Funny really,
> you're just *too* nice—kind of annoying.
> Might be why we're breaking up.

Cox and Dabney slouch on a sofa

 COX
 We oughtta get goin'.

 DABNEY
 Yeah, but you're not driving. You been
 drinking.

 COX
 I had a drink or two... maybe, but you
 drank way more.

 DABNEY
 I don't know how much you drank, but
 you're waaaay more drunk than I am.

 COX
 So not drunk. You're the lightweight.

 DABNEY
 Why always with the slams?

 COX
 You said I was drunk.

 DABNEY
 But I didn't call you names. Seriously,
 any chance to make me feel bad.

 COX
 I made you feel bad?

 DABNEY
 Yeah. You did.

 COX
 I'm sorry.

 DABNEY
 S'okay.

They hug, mumbling sentimentally.

 COX
 Maybe neither of us should drive.

 DABNEY
 Yeah, I'd rather stay here with you
 anyway.

 CHEYENNE
What's going on with you and Li?

 SELBY
Why?

 CHEYENNE
I thought you guys were having some
trouble.

 SELBY
We were. We are, I guess.

 CHEYENNE
You should make your real feelings
known.

 SELBY
I suppose I could.

 CHEYENNE
It's a cliché, but it really is all
about communication. If you really want
this relationship to work, say so.

 SELBY
Yeah, okay, fine. I got it.

 CHEYENNE
Tell me that you're going to sit Li down
and share what's in your heart.

 SELBY
Look, I appreciate your intentions here,
but you're a little insistent,
considering... *your* track record.

 CHEYENNE
Ouch! Really? That's low.

 SELBY
You know I don't mean to hurt your
feelings, just don't... push.

 CHEYENNE
You really think I'm not aware of my
"track record"? I thought maybe you
could learn from my mistakes.

Cheyenne shuffles out. Selby feels terrible.

SHELBY
Your work's been suffering.

PENN
I get my work done, don't I?

SHELBY
You've slowed down. You're preoccupied.
Your coworkers have noticed the change.
You need to tell me what's going on.

PENN
I'll... work on it. I'll... speed up.

SHELBY
Look, there's an issue here. I need to
understand it.

PENN
It's personal, okay?

SHELBY
Fine. I won't tell anyone, but if it's
affecting your work, I need to know.

PENN
I don't think you *need* to know.

SHELBY
I do if you want to keep working here.

PENN
I'm not telling you about my personal
life. This is inappropriate.

SHELBY
You're not being fired because you won't
tell me about your personal life. This
is about your poor performance, but if
there are extenuating circumstances...

PENN
I'm being fired here?

SHELBY
That's completely up to you.

Penn considers long and hard, then gets up and leaves.

PENN
I quit.

 MICKEY
 ZZZZZZ...

 NATCH
 HEY!

Mickey wakes in a panic.

 MICKEY
 What! What! What is it!?

 NATCH
 You were snoring.

 MICKEY
 Oh, my God. You didn't have to scare me
 though did you?

 NATCH
 I tried it quietly, but it didn't work.

 MICKEY
 No you didn't. You're messing with me
 yet again. I snored a little and you
 yelled.

 NATCH
 No, I just said it softly, "Hey, you're
 snoring", but it didn't wake you.

 MICKEY
 No, you did not.

 NATCH
 You were asleep when I said it. How
 would you know if I said it?

 MICKEY
 Only half asleep.

 NATCH
 You snore when you're half asleep?

 MICKEY
 I guess so.

 NATCH
 Then how come you didn't hear yourself
 snore?

This one stops Mickey. Natch smiles.

ABOUT THE AUTHOR

An award-winning short filmmaker, Dave Kost graduated from New York University's prestigious graduate film program and has written, directed, and acted in over a dozen varied and successful short films over the last 25 years. His films have played in major festivals and on television all around the world. In addition to his short films, Dave is the writer and director of *Safety on Set*, the authoritative work about safety on film sets for students distributed internationally by First Light Video. He is currently a professor at Chapman University's Dodge College of Film and Media Arts where he has taught filmmaking for 14 years. At Chapman, he helped to build the university's world-renowned graduate and undergraduate film programs and created the first of its kind BFA degree in Screen Acting: an interdisciplinary degree offered between Chapman's theater and film departments. Prior to Chapman, Dave worked for many years on professional film and television productions and was founding faculty at the New York Film Academy. Dave currently enjoys living in Long Beach, California with his wife, Kelly and golden retriever, Murphy.